gardensgardens**GARDENS**gardensgardens

national geographic *moments*

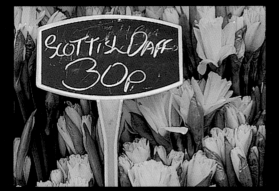

GARDENS

by Leah Bendavid-Val

 NATIONAL GEOGRAPHIC

Washington, D. C.

It is hard for a photograph of a garden to live up to the complex beauty of an actual garden. You would expect such a delightfully visual subject to be easy to capture on film because it doesn't move, although a garden is never really still. Plants evolve over a season; light and weather change over the course of a day, an hour, or even minutes. ⌁ But photographers who are attentive to a garden's quiet or windswept moods, who have a honed sense of framing and sensitivity to color, texture, and structure, may, if they are so inclined, produce accomplished photographs. When a photographer combines his personal viewpoint with the gardener's quite different vision—when he pays homage to the horticulturist's seductive creation and also imbues it with his own way of seeing—memorable pictures can result. Pioneering photographer Charles Platt, for example, loved the way cameras recorded precise detail, and he displayed his enthusiasm in his book *Italian Gardens,* published in 1894. Photographer Eugène Atget, on the other hand, portrayed early 20th-century French gardens looking alluringly chaotic. National Geographic photographers from Jacob Gayer in

Gardens

the 1920s to Sam Abell today have found and photographed the diverse poetries of gardens. Seventy-five lyrical and layered images by them and others, all from the National Geographic archive, are collected in this volume. ❧ In March 1905 the Society published "The Gardens of the West," a magazine story about government irrigation projects. The text proclaimed that water would "make gardens out of nearly one million acres…." Accompanying photographs show a garden-like beauty in vast America. This was the first in a long line of Geographic garden stories—26 followed, most featuring more conventional gardening. Gardens were never at the top of the Geographic's list of important topics, but the magazine's first editor, Gilbert Hovey Grosvenor, delighted in them and guessed that Society members would feel the same. He also apparently saw the close connection between planting for food and planting for pleasure. ❧ As far as we know, plants began to be domesticated for subsistence about 10,000 years ago. The first decorative gardens seem to have been grape arbors in about 2500 B.C. Grapes made tasty food and wines but were also mentioned poetically, along with pomegranates, apples, and figs, in the Old Testament's Song of

Solomon. ❧ Before that came the mythical Garden of Eden, a lush and benevolent place that nurtured "every tree that is pleasant to the sight and good for food." Seekers have attempted to locate that legendary paradise for centuries. Artists have rendered it as a tranquil, spiritual haven. The word "paradise" derives from the ancient Persian word *pairidaeza,* which means fenced garden. There is a sense that this dreamy place is removed, fenced off from daily cares. ❧ Some long-ago gardens are still remembered for their grandeur: the Hanging Gardens of Babylon, created by King Nebuchadnezzar with the labor of his slaves and peasants in 540 B.C., for example, and the Persian paradise garden of King Darius the Great, which blossomed around 485 B.C. If photography had existed in those days perhaps these gardens would not have been quite so exquisitely memorialized on carpets and ceramics. ❧ Styles and personalities of gardens change in response to the great swings of history. In harsh medieval times, monks in monasteries quietly practiced gardening. Gardens were sanctuaries, but tilling them linked the gardener to the worldly life outside. In the Renaissance that followed, opulent palace and estate gardens

bloomed once again. ❧ Plant travel between Europe and America began with the voyage of Christopher Columbus in 1492. In 1510 sunflowers from South America appeared in Spain. Arabs influenced Italian gardens, and English-style gardens made their way to Russia. Yet countries held on to their own distinctive garden styles: Dutch, Chinese, French, and Japanese gardens stood apart from English and Italian ones. Great public figures such as Thomas Jefferson and Leo Tolstoy ardently cultivated estate gardens that showcased the indigenous fruits and flowers of their native American and Russian homelands. ❧ Gardening is fundamentally a personal activity. In rural and city gardens, in ornamental gardens and kitchen gardens, citizens express their proud or humble relation to the Earth. In the 17th and 18th centuries, some, who had enough space, planted kitchen gardens based on astrology. They featured herbs planted in raised beds that were fenced to keep out animals. Nowadays even an urban dweller finds a windowsill or a small patch to plant a favorite herb or flower. ❧ The word "horticulture" seems to have appeared late in the 17th century. Horticultural societies around the United States sponsored fairs

where amateur and professional gardeners could display their wares. By the end of the 19th century, gardening had become a big business, leading to the production of garden tools, seeds, fertilizers, and catalogs. ❧ Early in the 20th century Geographic editors were beguiled by the realism of color photography and the prospect of new color technologies. The Autochrome, a glass-plate, color technology introduced in France in 1904, especially enchanted Geographic editors, and they looked for feasible ways to translate its shimmering color into magazine print. The first Autochrome appeared in the July 1914 issue. It was titled "A Ghent Flower Garden," and the final sentence in a long caption read, "The picture makes one wonder which the more to admire—the beauty of the flowers or the power of the camera to interpret the luxuriant colors so faithfully." ❧ It should be no surprise that a garden was chosen as the subject for that first full-color photograph in NATIONAL GEOGRAPHIC magazine. Autochrome exposures had to be long—one or two seconds at a lens setting of f8 in good light, 20 times the period required for black-and-white—and most gardens stood relatively still for the camera. ❧ But thrillingly colorful as gardens were, Grosvenor

believed photographs of them needed people to show scale and hold reader interest. "The Palace of Versailles, Its Park and the Trianons," a January 1925 story, starts at the main gate of Versailles, where throngs of tourists mill about the plaza. More than a dozen peopled garden scenes follow. One—set in a grove of carefully planted trees—shows a reenactment of blindman's buff, complete with costumes worn in the time of Marie-Antoinette. ❧ "Nautical Norfolk Turns to Azaleas," published in May 1947, opens with a young girl embracing a profusion of flowers and wearing some in her hair. This pretty-girl-with-flowers approach was used in "Kew: The Commoners' Royal Garden," April 1950, and in innumerable other stories. ❧ It is striking, looking back at those pictures now, to see that the gardens themselves have a timeless quality, but the people, dressed in the fashions of the day and posed in the photographic style of the era, appear charmingly dated. That duality is apparent in this small book. But above all these pictures, both nostalgic and timeless, remind us how widespread and varied is the impulse to garden. ❧

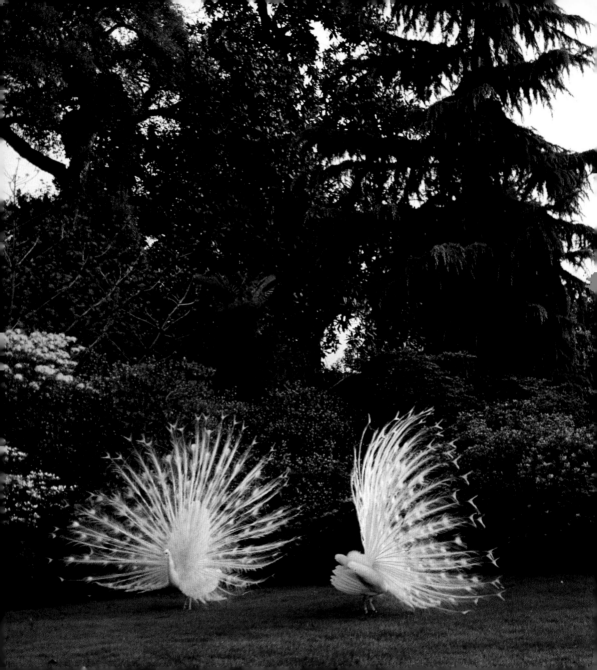

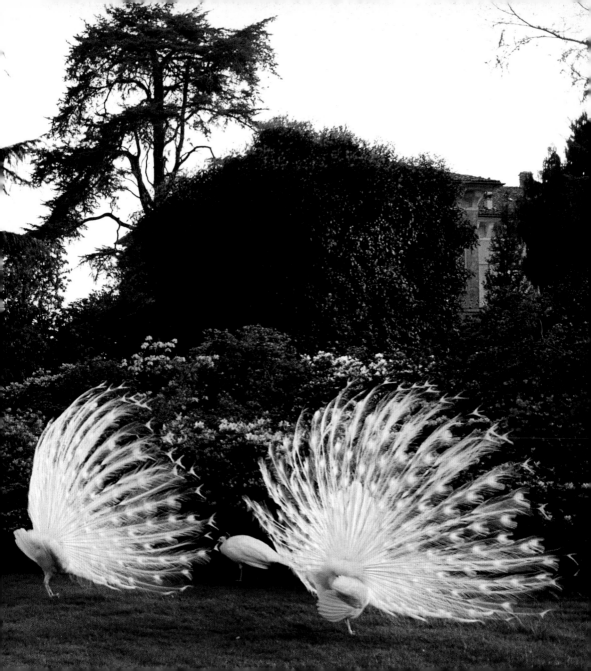

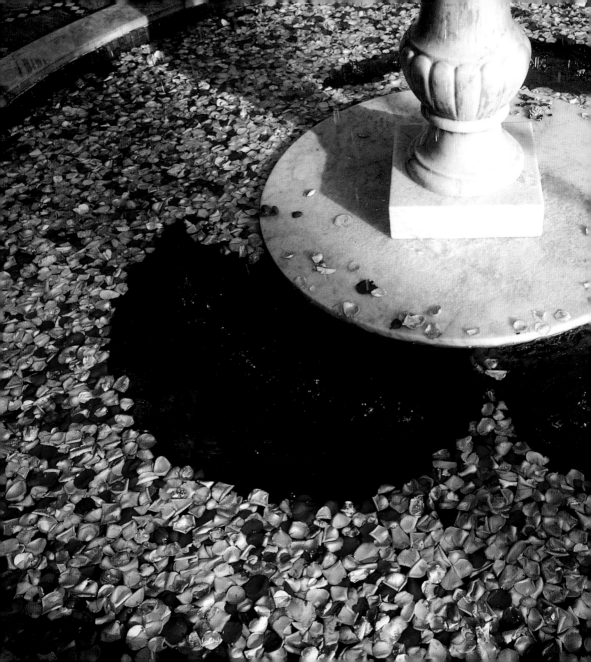

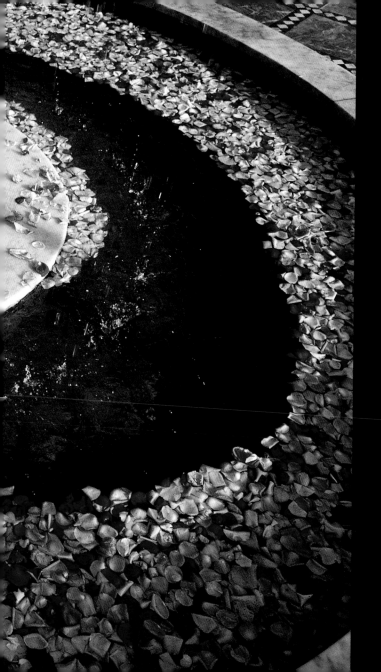

MARRAKECH, MOROCCO
1989
SAM ABELL

preceding pages
LAKE MAGGIORE, ITALY
1989
SAM ABELL

ROMANIA
1934
WILHELM TOBIEN

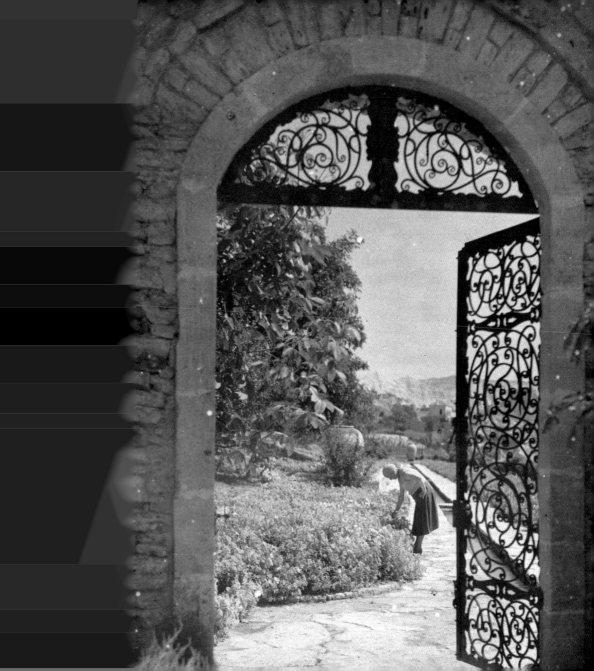

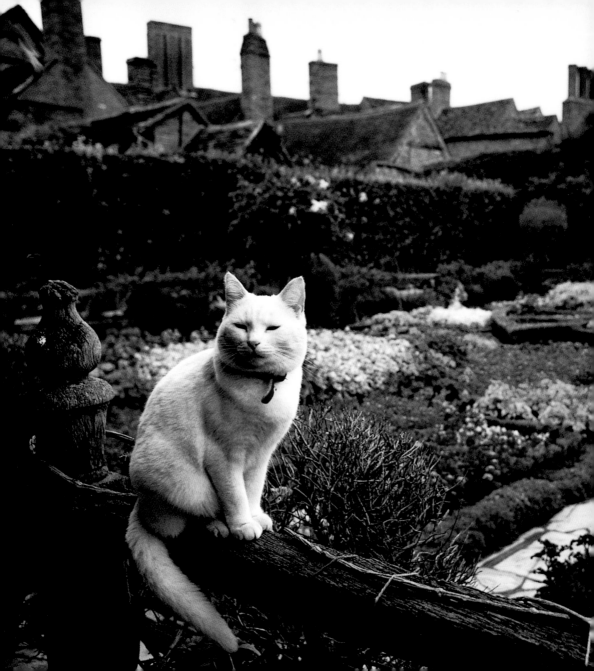

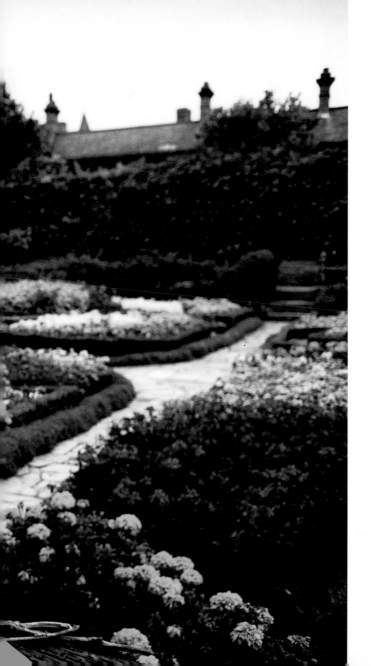

STRATFORD, ENGLAND
1983
SAM ABELL

following pages
WASHINGTON, D.C.
1931
JACOB GAYER

WASHINGTON, D.C.
1926
JACOB GAYER

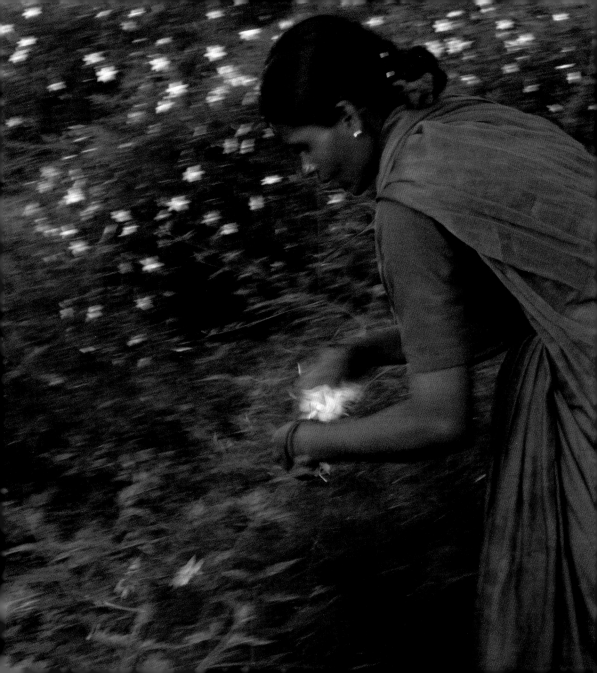

INDIA
1998
ROBB KENDRICK

following pages
MARRAKECH, MOROCCO
1989
SAM ABELL

CYPRESS GARDENS,
FLORIDA
1947
ROCKEFELLER
CENTER, INC.

NEAR AMSTERDAM,
THE NETHERLANDS
1997
LYNN JOHNSON

KENT, ENGLAND
1989
SAM ABELL

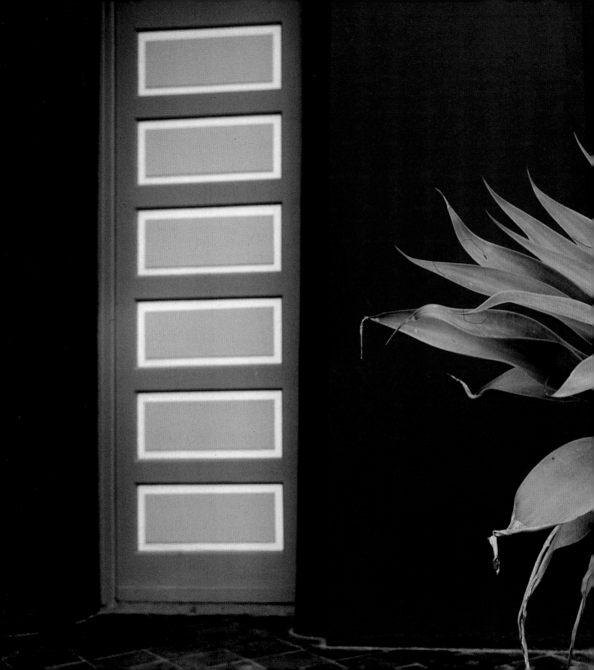

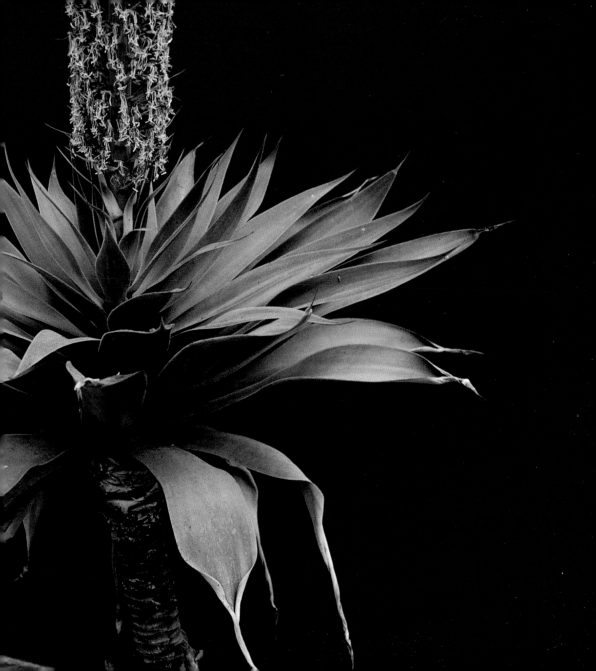

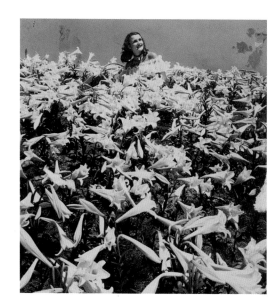

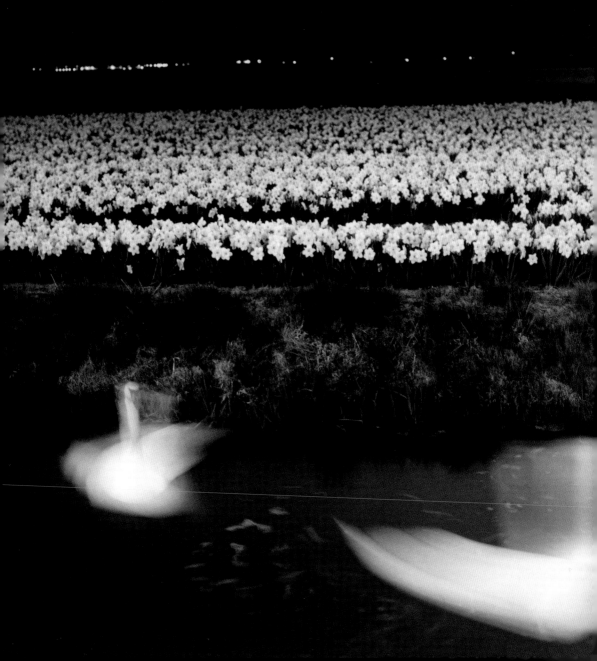

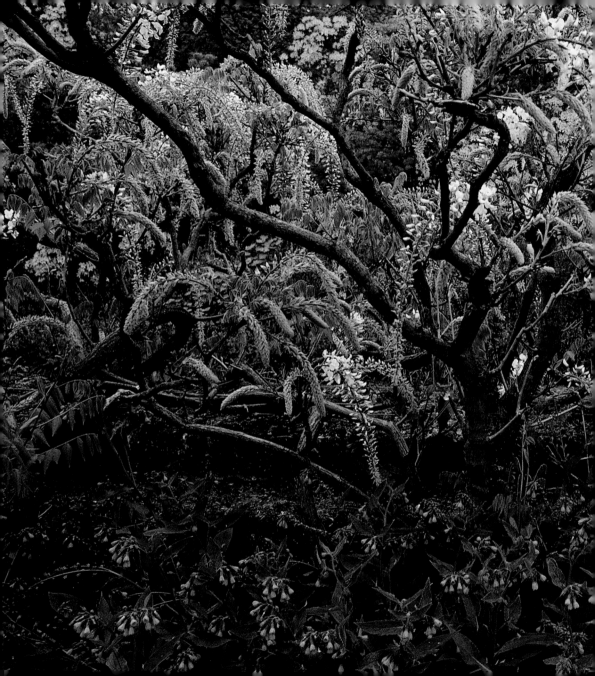

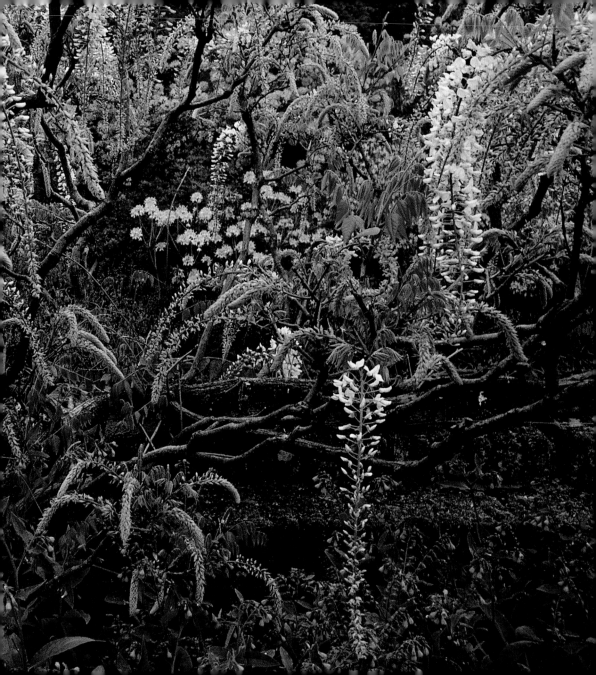

Gardeners and photographers

share a challenge —— to find a balance between their experiences of untamed nature and their desires to impose a personal aesthetic on nature's artlessness. Successful solutions to the challenge abound. We tend to think of gardens in the context of a season or, occasionally, as a multiyear expression of one gardener's devotion. But when photographer Sam Abell, moved by a potter's garden in Hagi, Japan, asked the potter why the garden was so affecting he was given its age—it was 600 years old. ❧

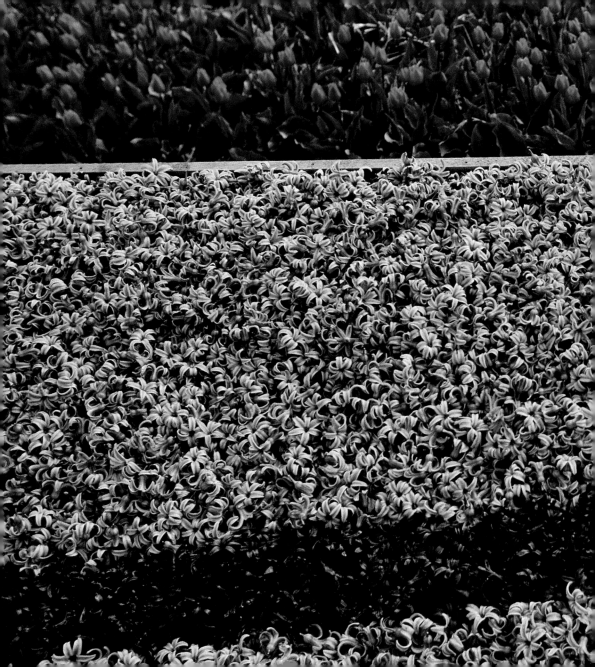

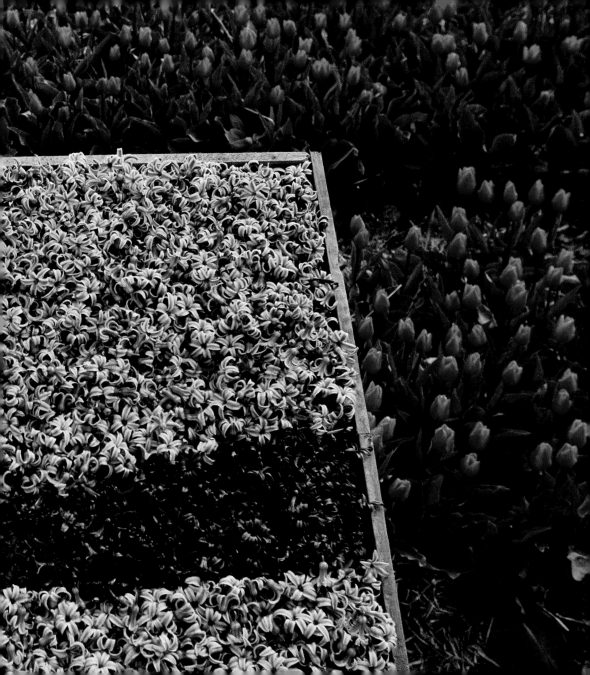

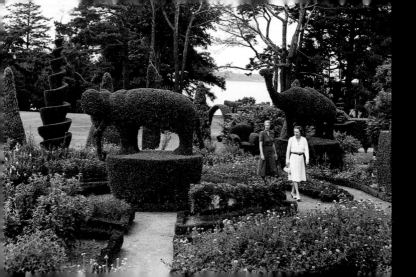

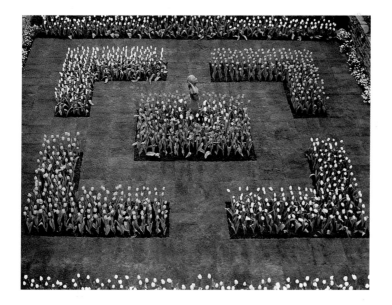

CALIFORNIA
1929
CHARLES MARTIN

preceding pages
KEUKENHOF,
THE NETHERLANDS
2001
SISSE BRIMBERG

PORTSMOUTH,
RHODE ISLAND
1948
WILLARD R. CULVER

GRAND CENTRAL PALACE,
NEW YORK, NEW YORK
1947
EWING GALLOWAY

following pages
DEVON, ENGLAND
1989
SAM ABELL

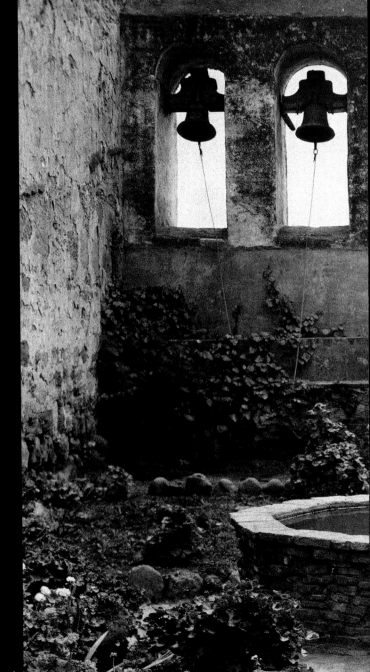

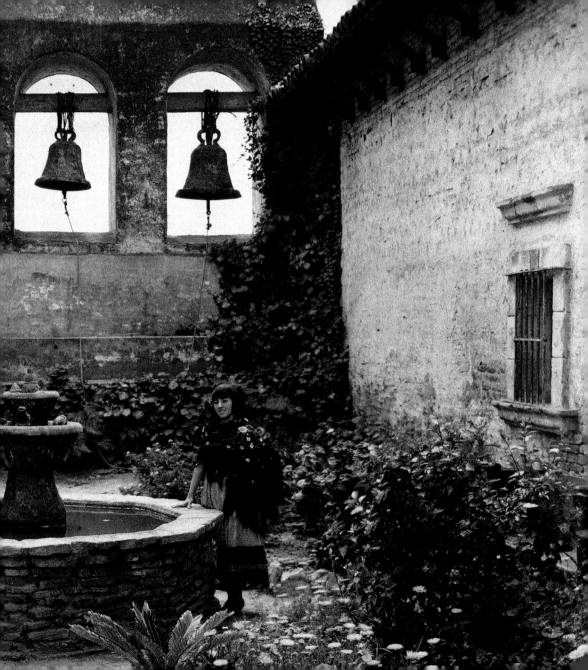

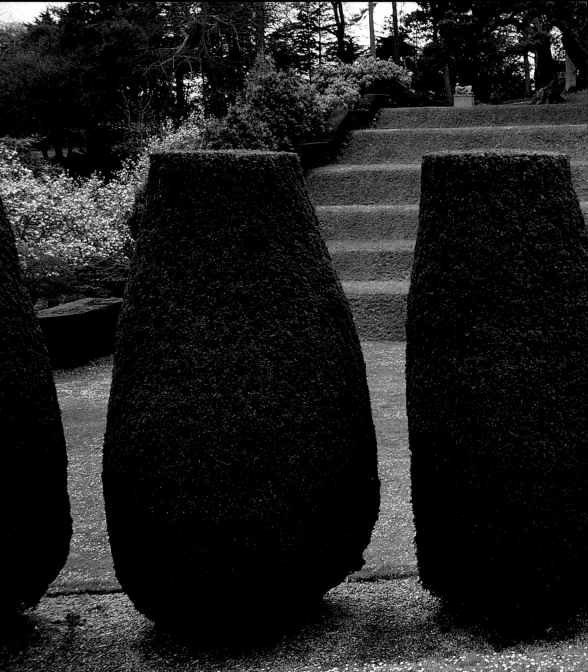

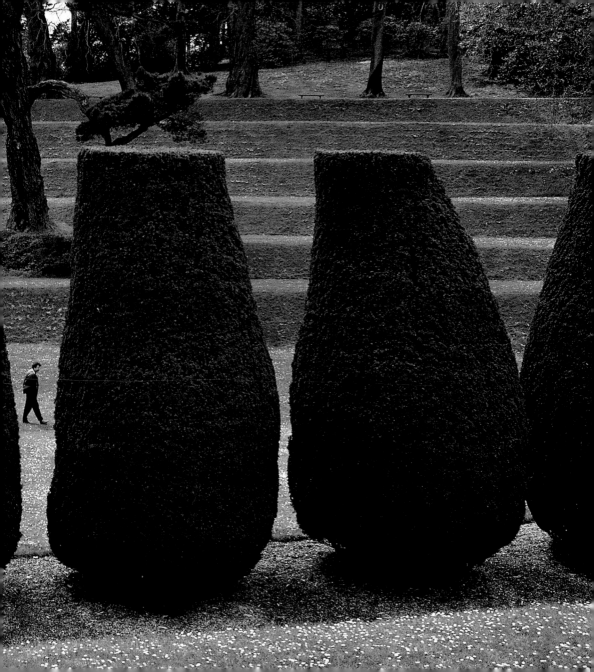

BELLAGIO, ITALY
1989
SAM ABELL

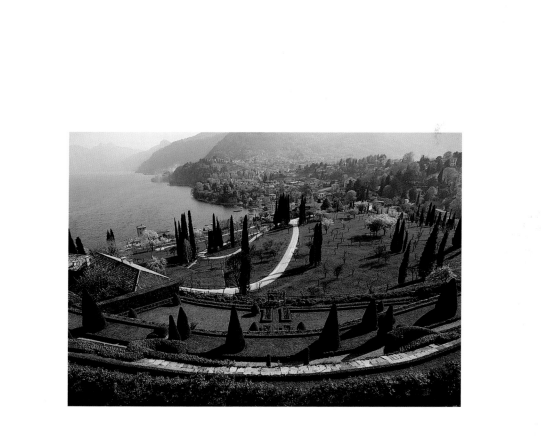

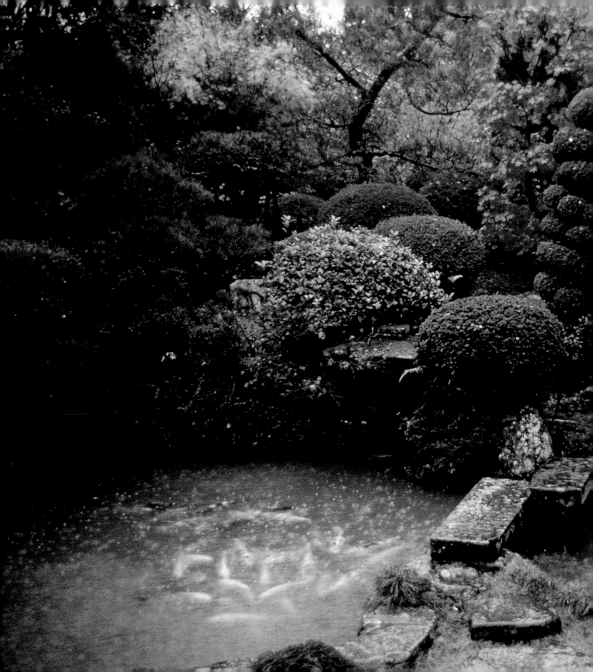

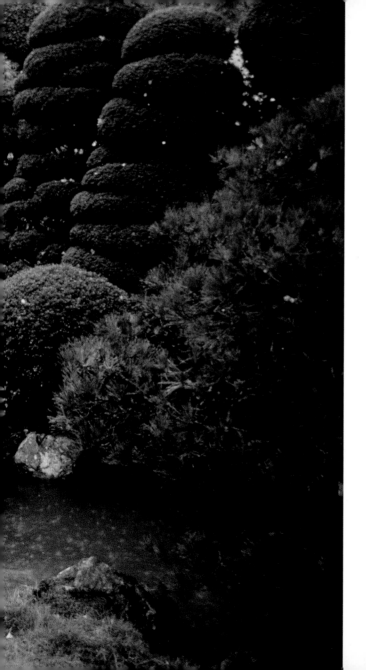

HAGI, JAPAN
1980
SAM ABELL

following pages
KYOTO, JAPAN
1989
SAM ABELL

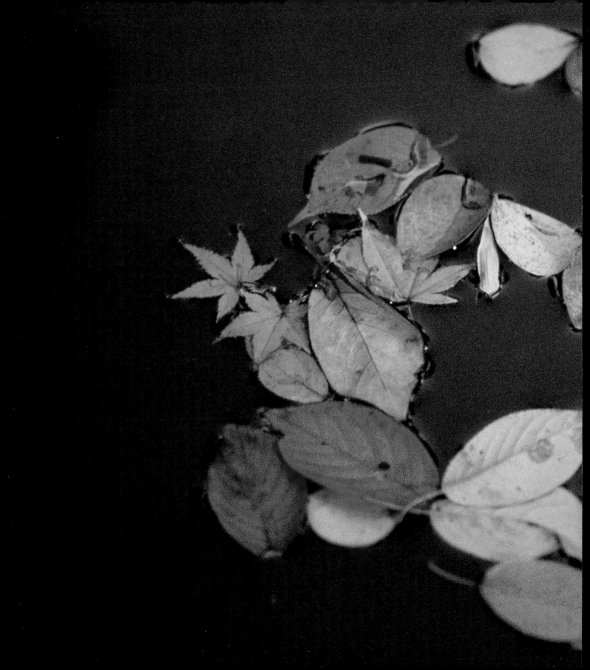

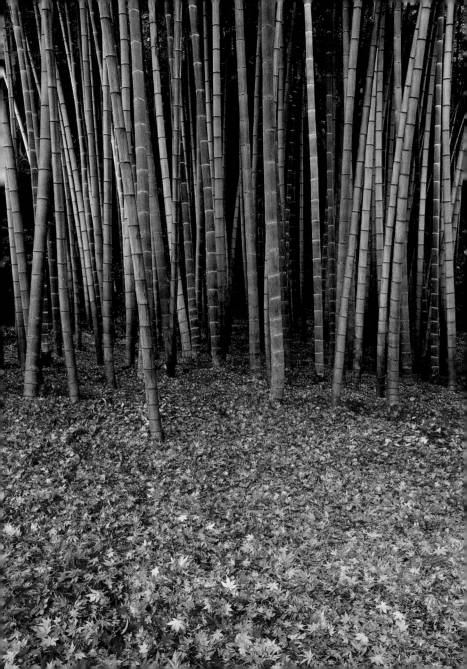

KYOTO, JAPAN
1989
SAM ABELL

In July 1914, deep inside a story

about beetles and moths, editors inserted

the first true-color photograph published in NATIONAL GEOGRAPHIC maga-

zine. It still looks fresh, as you can see on the next page. The Autochrome

process used by the photographer was enthusiastically embraced, and

colorful gardens became a central Autochrome theme. Usually the

garden was brightened further by the presence of a pretty woman dressed

in the fashion of the day. ❧

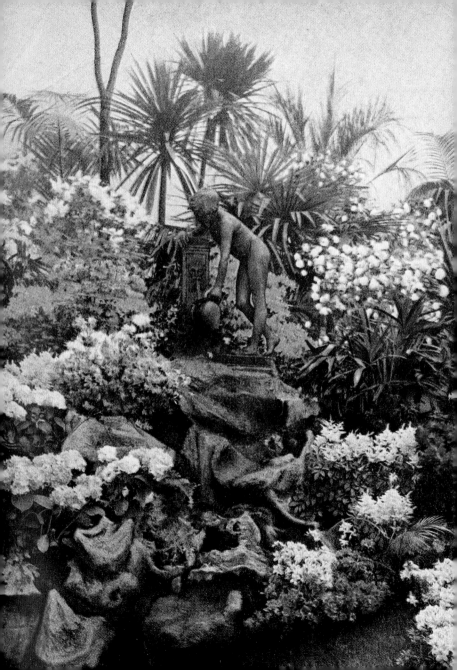

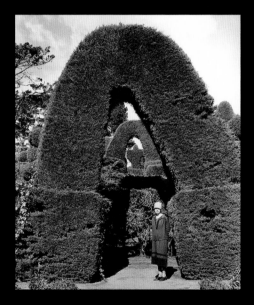

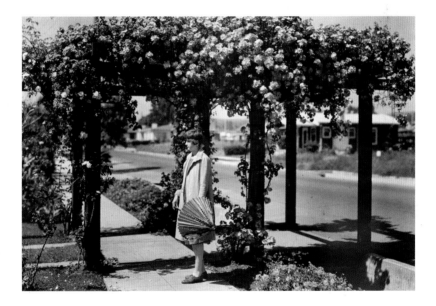

WASHINGTON, D.C.
1926
CHARLES MARTIN

following pages
SKANE, SWEDEN
1934
GUSTAV HEURLIN

WELLE, ENGLAND
1992
SAM ABELL

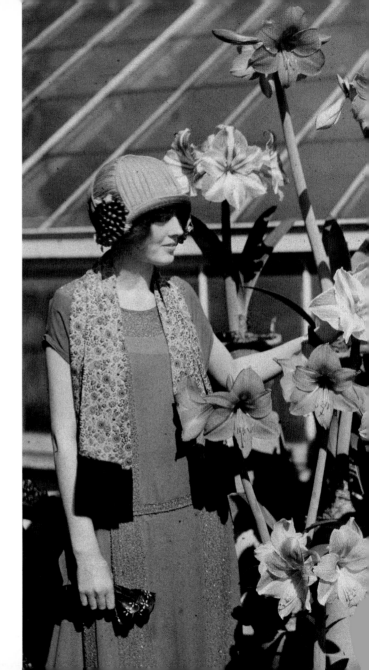

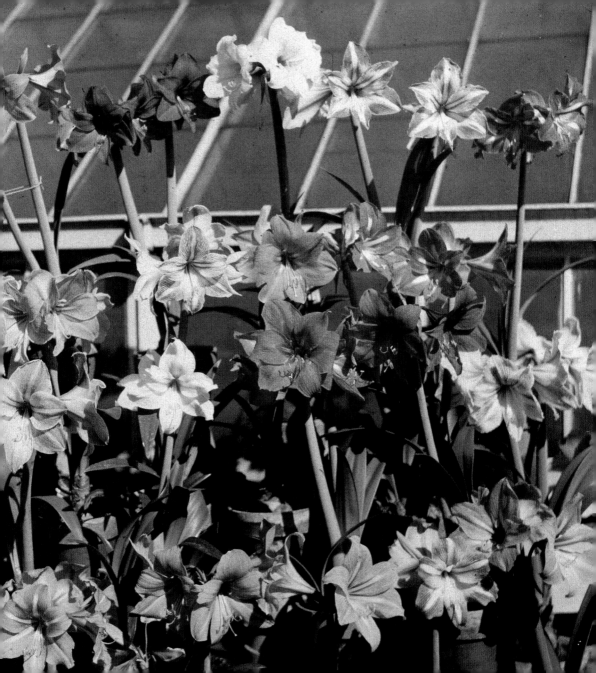

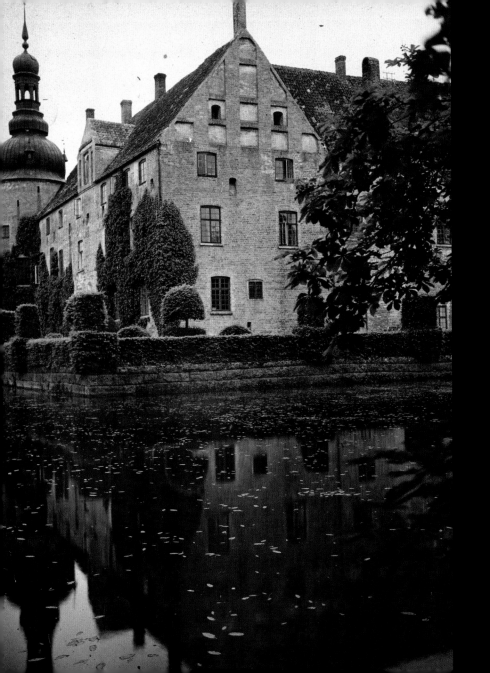

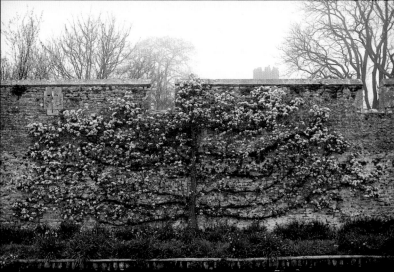

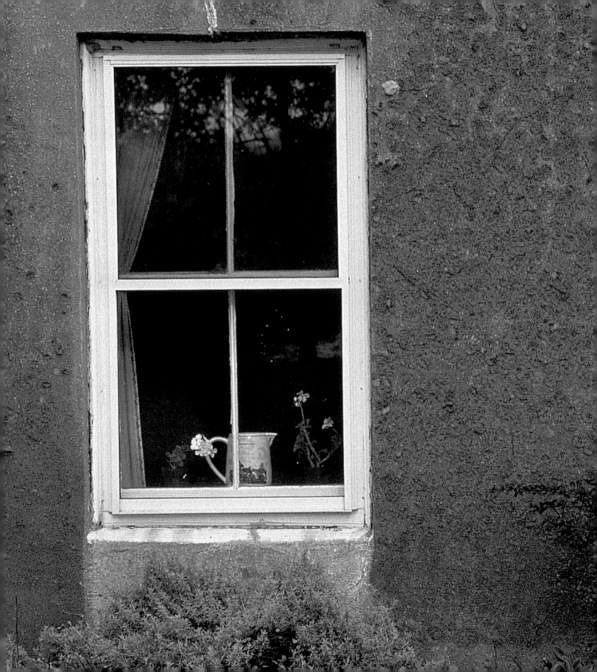

MARTHA'S VINEYARD,
MASSACHUSETTS
1997
STEPHEN SHARNOFF AND
SYLVIA DURAN SHARNOFF

following pages
LONGFORGAN, SCOTLAND
1946
B. ANTHONY STEWART

NANTUCKET,
MASSACHUSETTS
1944
B. ANTHONY STEWART

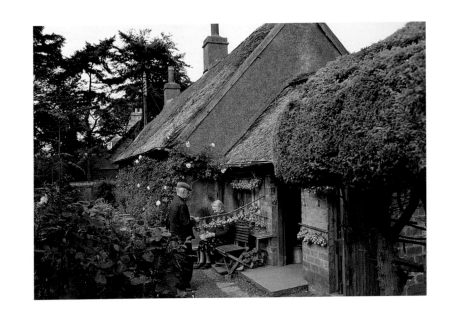

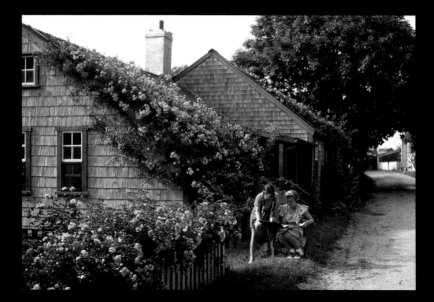

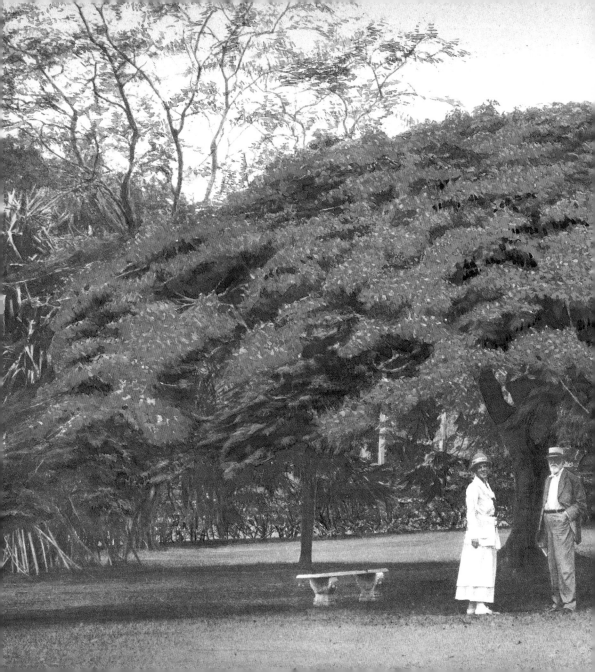

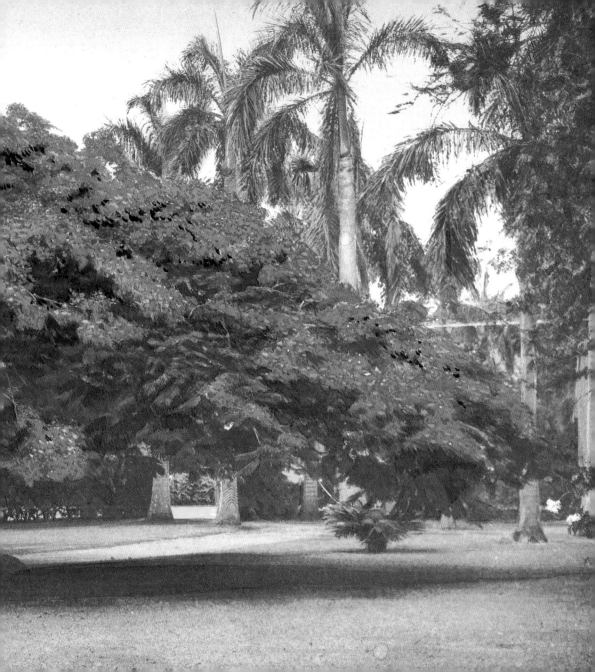

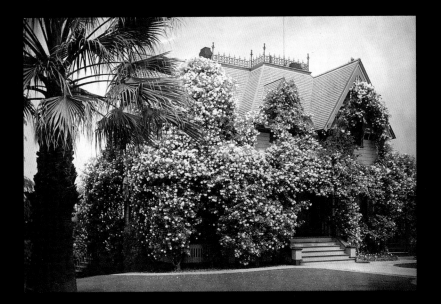

REDLANDS, CALIFORNIA
1910
PHOTOGRAPHER
UNKNOWN

preceding pages
HONOLULU, HAWAII
1924
GILBERT H. GROSVENOR

following pages
CALIFORNIA
1946
PHOTOGRAPHER
UNKNOWN

MANAGUA, NICARAGUA
1944
LUIS MARDEN

LAKE COMO, ITALY
1989
SAM ABELL

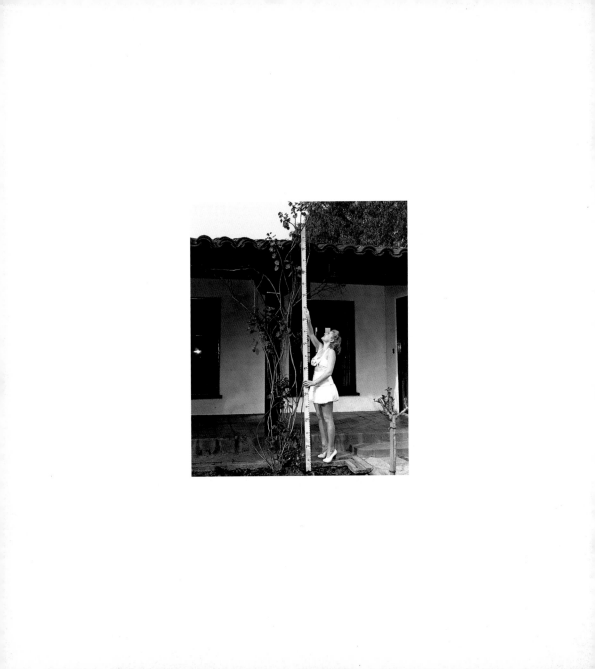

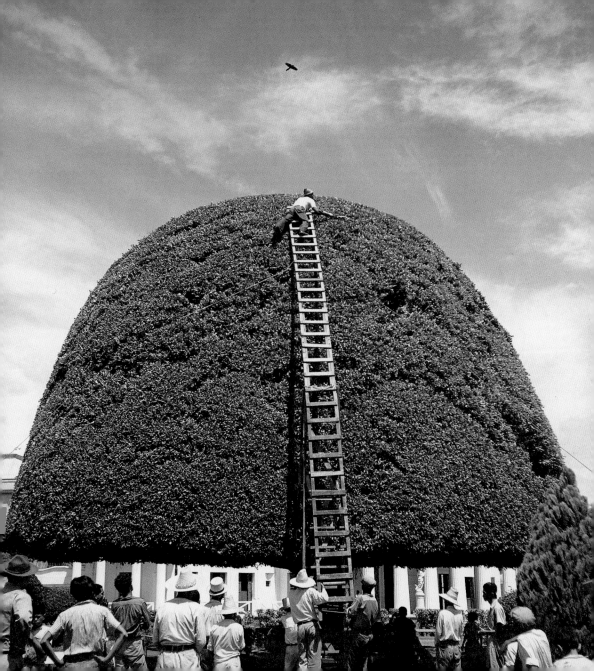

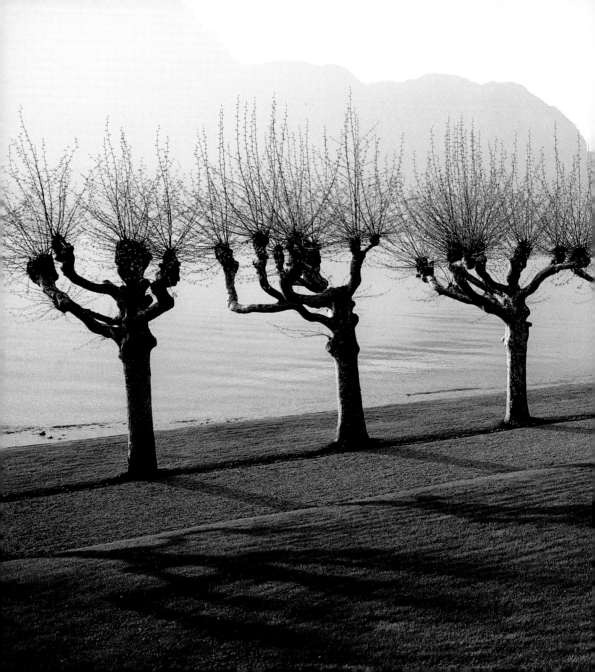

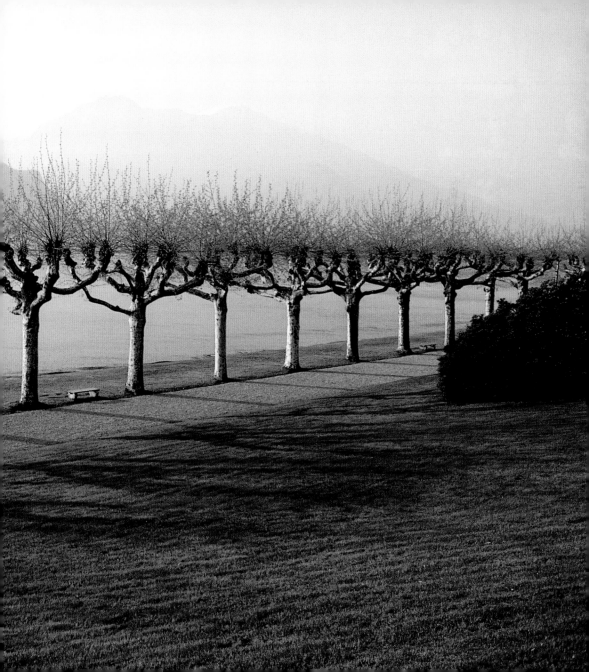

Gardening is work: Seeds are

planted, cultivated rows are thinned, weeded, and watered; greenhouses are built; tender shoots are covered for winter. Yet gardeners find a haven and creativity in their plots, and the hauling, bending, and lifting have connected them to these pleasures since ancient times. It's not surprising, therefore, that gardens are everywhere—on urban rooftops, vacant lots, country estates, kitchen windowsills, and backyards around the world. ❧

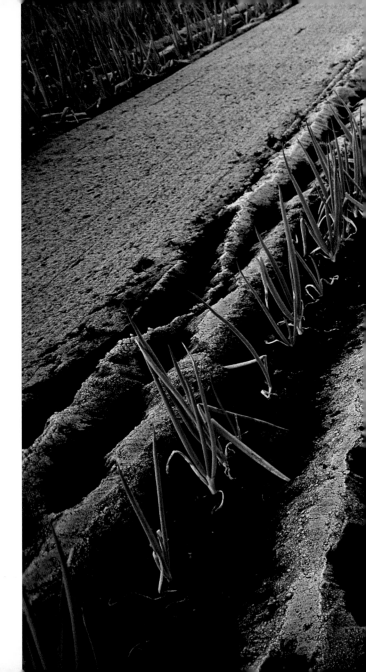

TOKYO, JAPAN
2000
SAM ABELL

following pages
**SUAMAREZ PARK,
GUERNSEY ISLAND**
1938
B. ANTHONY STEWART

NORTHERN IRELAND
1993
SAM ABELL

KENT, ENGLAND
1989
SAM ABELL

KYOTO, JAPAN
1989
SAM ABELL

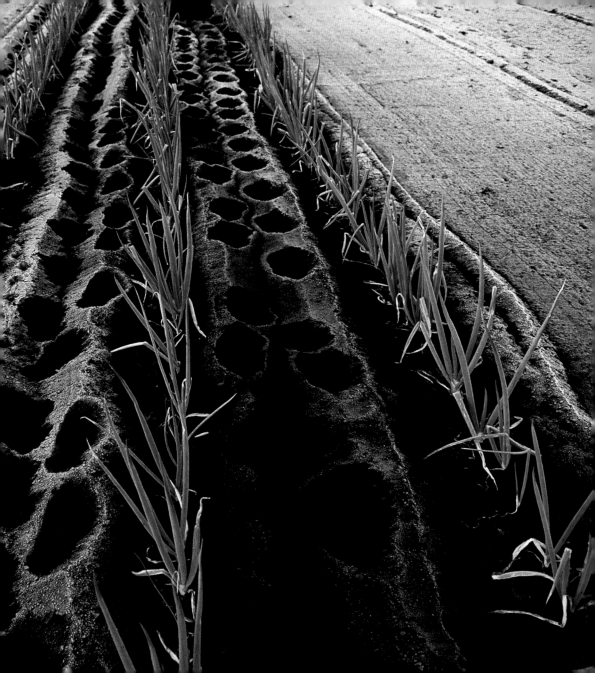

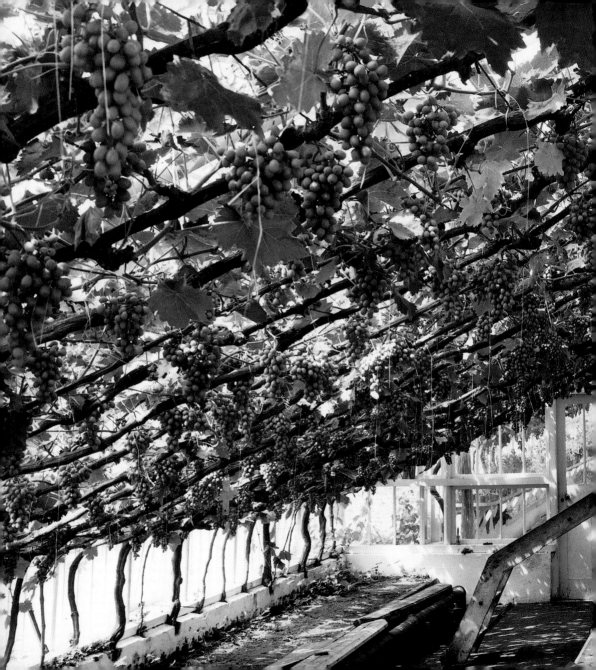

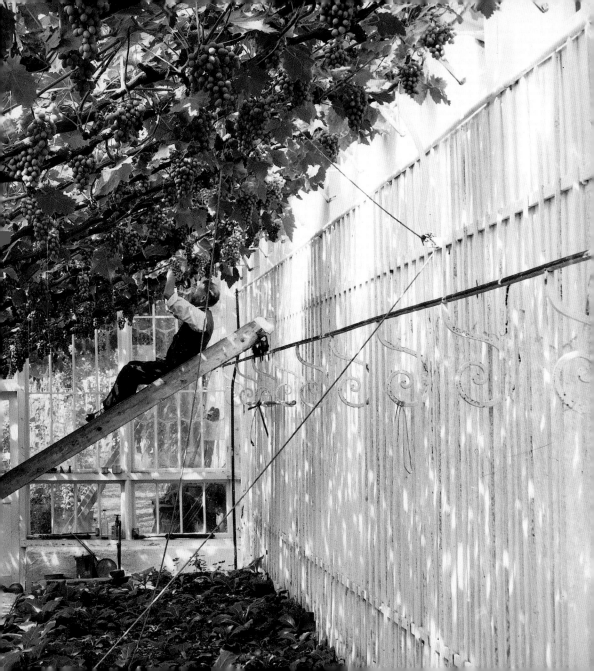

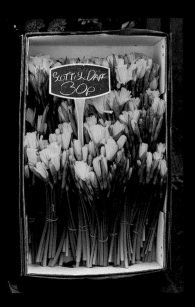

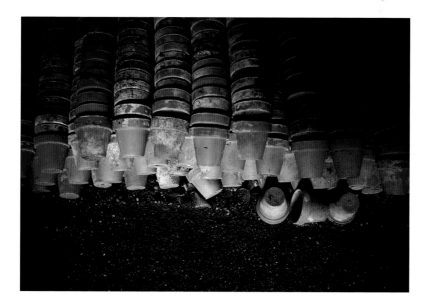

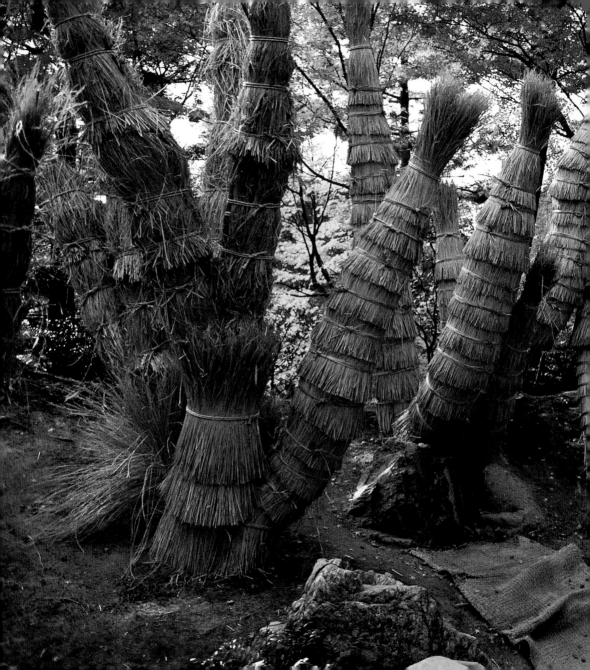

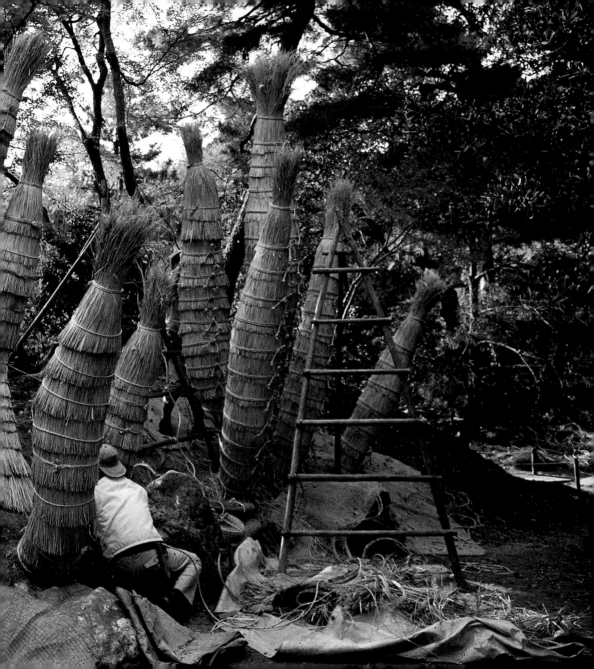

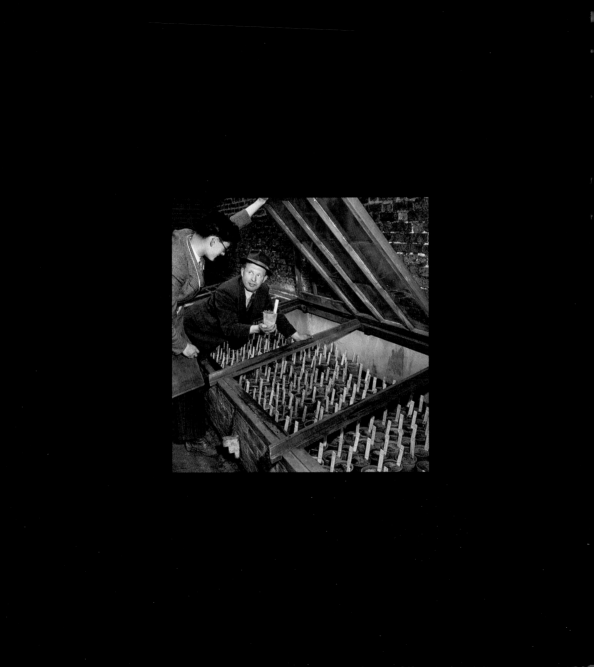

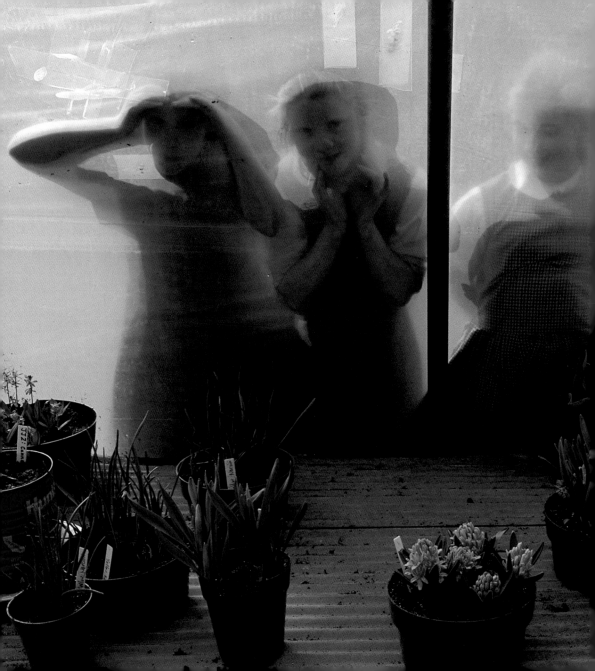

DEER SPRING, CONNECTICUT
1994
JOEL SARTORE

preceding pages
KEW GARDENS, LONDON,
ENGLAND
1950
B. ANTHONY STEWART

KENT, ENGLAND
1989
SAM ABELL

following pages
SICILY, ITALY
1995
WILLIAM ALBERT ALLARD

Avid gardeners are rich and

poor, young and old, poets and busi-
nessmen. Their gardens reflect their financial resources, aesthetic

preferences, and personalities. Community gardens across America

bring people to a spot of land they otherwise wouldn't have access to.

In Philadelphia alone, vegetables flourish in more than 350 community

gardens. Community gardens also grow in Asia, Europe, and Africa—

an old idea with practical and aesthetic rewards. ❧

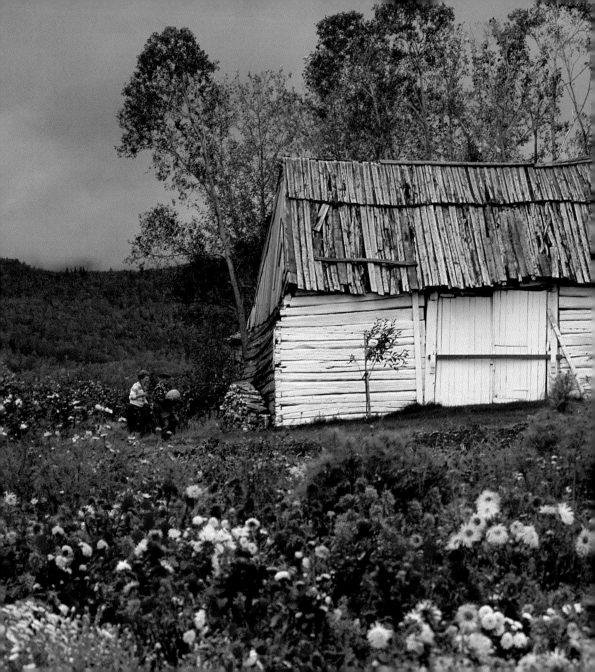

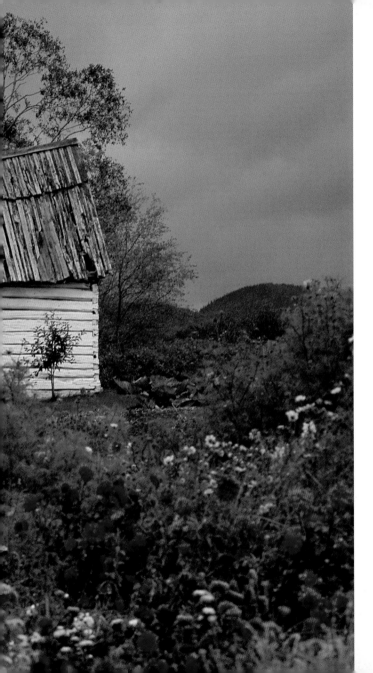

NEAR THE
ST. LAWRENCE RIVER
1994
TOMASZ TOMASZEWSKI

following pages
LONGWOOD GARDENS,
KENNETT SQUARE,
PENNSYLVANIA
1951
B. ANTHONY STEWART

PANAMA
1941
LUIS MARDEN

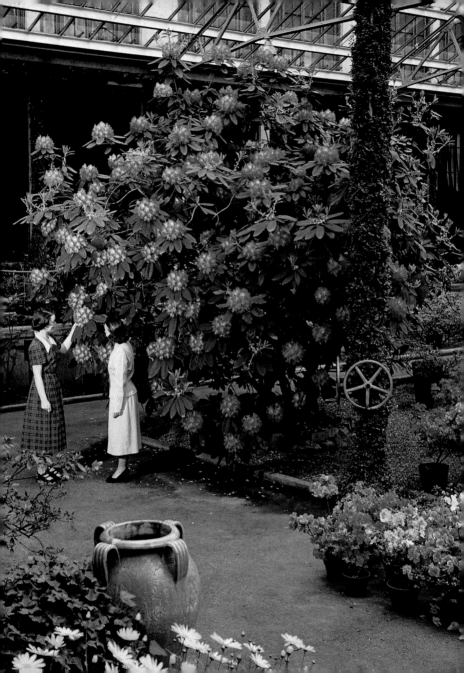

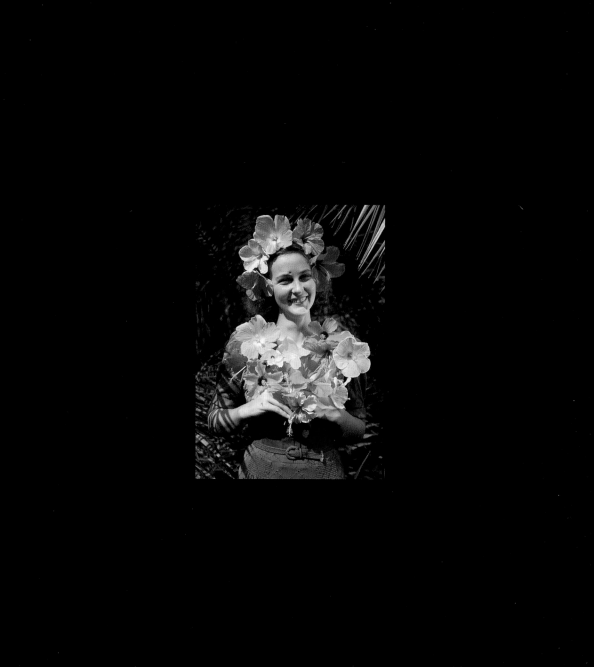

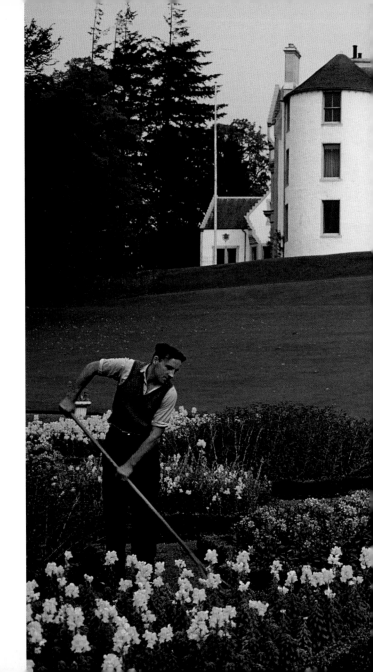

SCOTLAND
1957
KATHLEEN REVIS

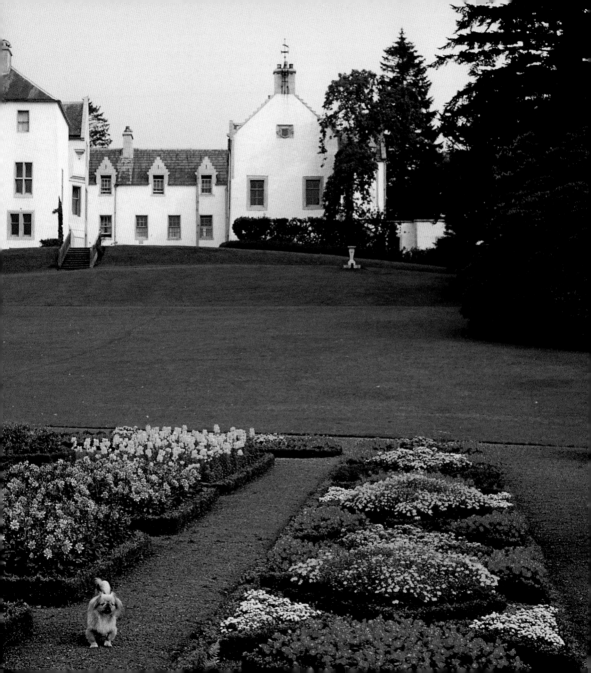

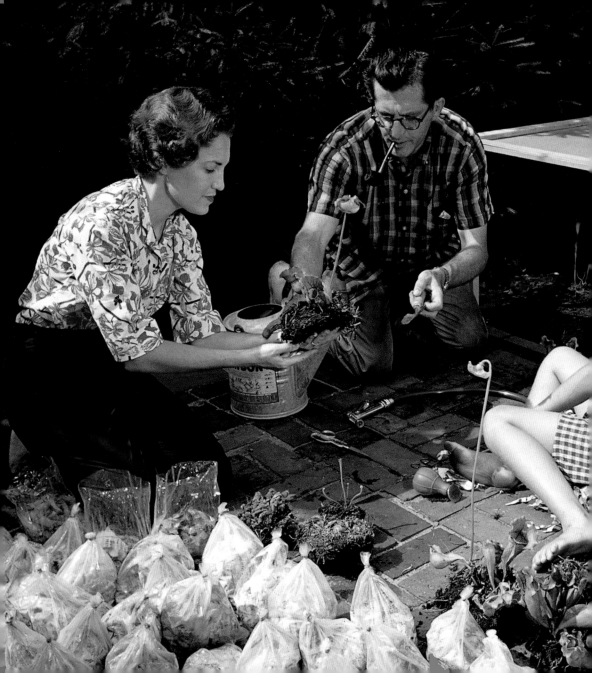

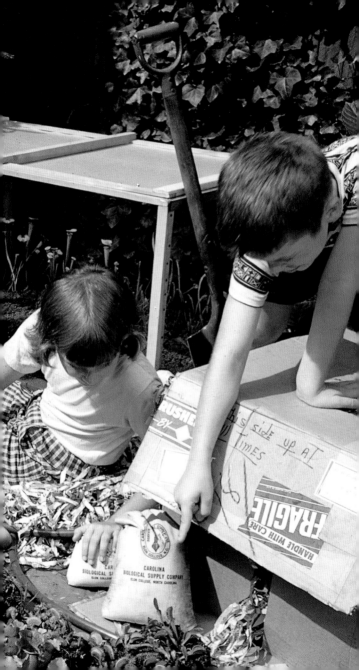

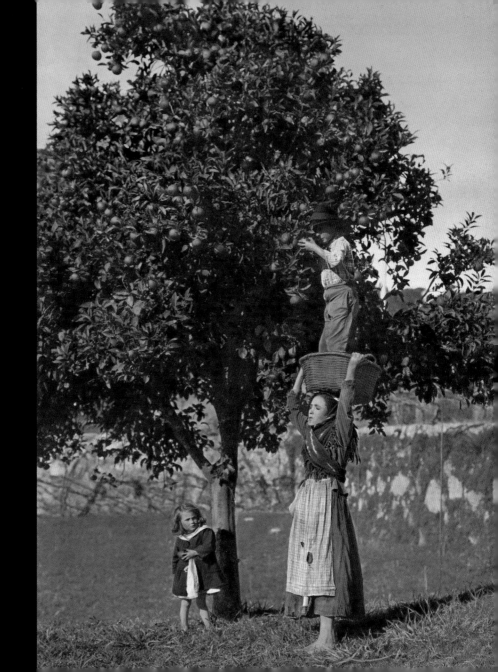

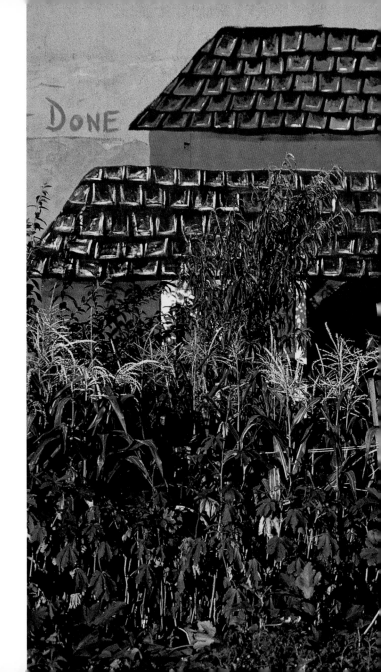

PHILADELPHIA, PENNSYLVANIA
1991
SAM ABELL

following pages
FORT SMITH, ARKANSAS
1916
REDNER PHOTO COMPANY

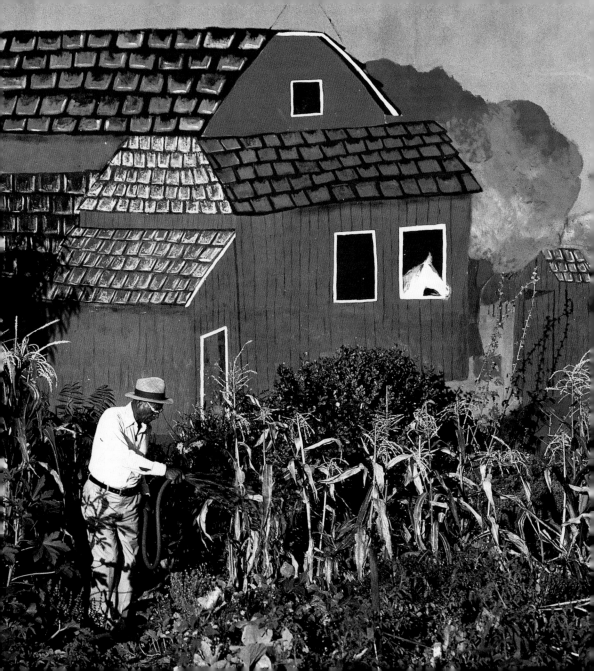

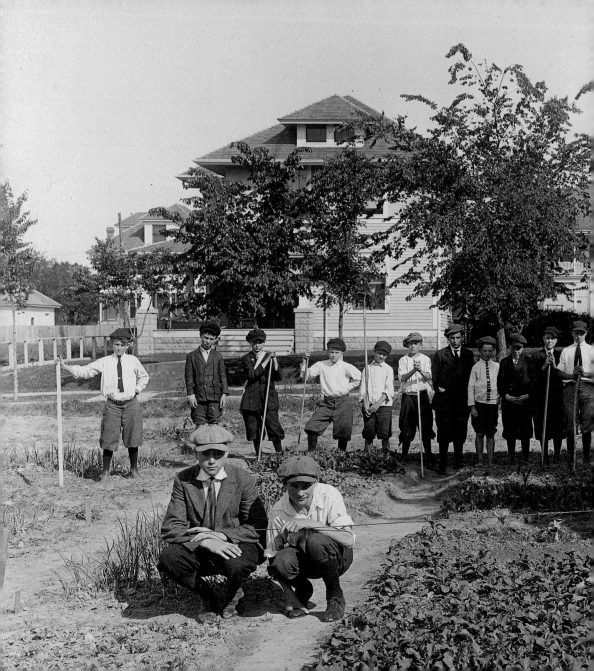

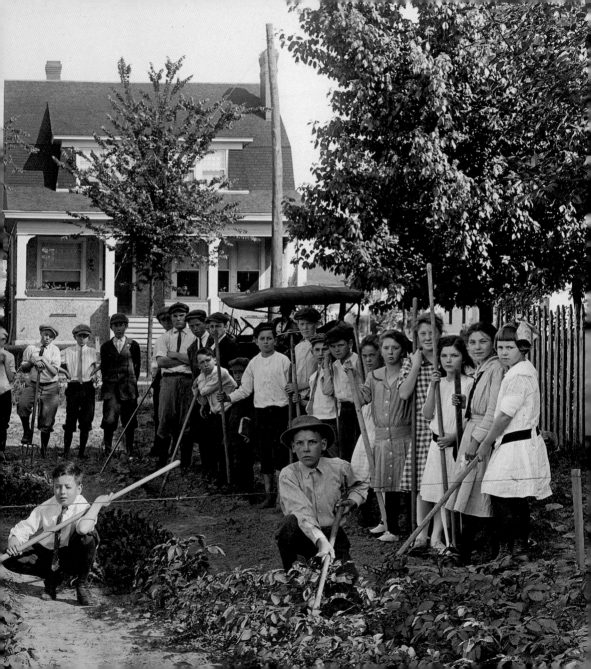

From season to season irises,

tulips, roses, and chrysanthemums are ready

for harvest. This may mean picking a few blossoms for the dinner table or harvesting thousands for an international market eager to add beauty briefly to everyday life. Flowers have stirred the imaginations of artists and inspired designers of carpets, tableware, clothing, and wallpaper. Photographers, too, have responded to the sublime mystery to be found in gardens.

AUGE, FRANCE
1932
GERVAIS COURTELLEMONT

following pages
SABBATHDAY LAKE, MAINE
1988
SAM ABELL

SAN DIEGO, CALIFORNIA
1991
SAM ABELL

ENGLAND
1989
SAM ABELL

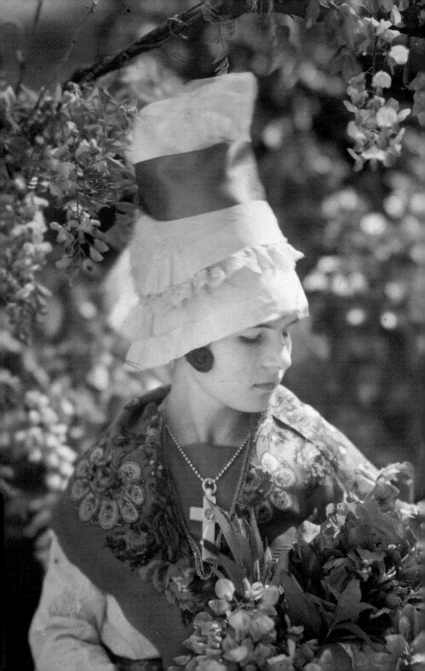

WESLACO, TEXAS
1939
B. ANTHONY STEWART

following pages
CALIFORNIA
1995
JIM RICHARDSON

KEW GARDENS,
LONDON, ENGLAND
1950
B. ANTHONY STEWART

NEAR KEUKENHOF,
THE NETHERLANDS
2001
SISSE BRIMBERG

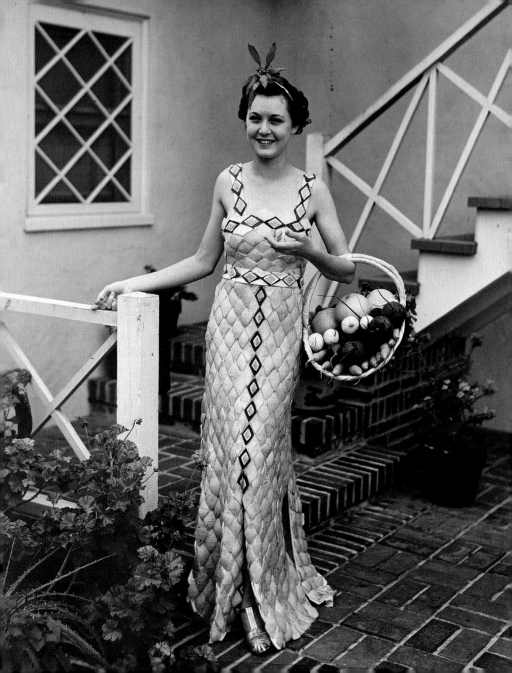

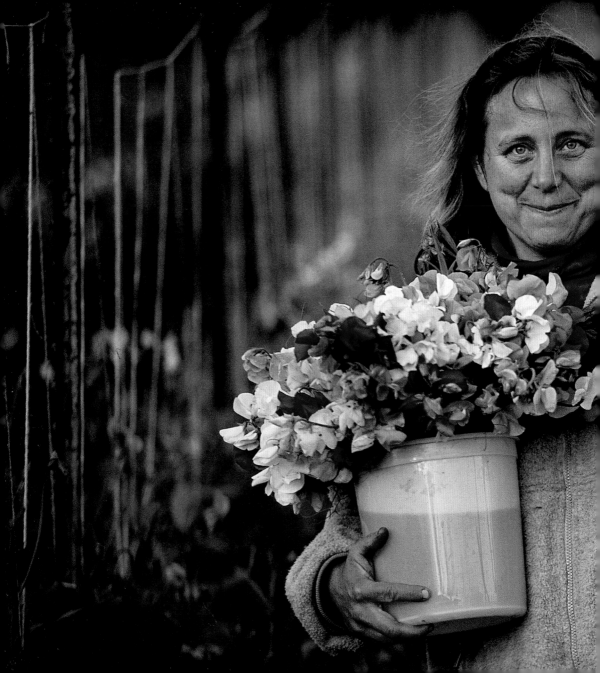

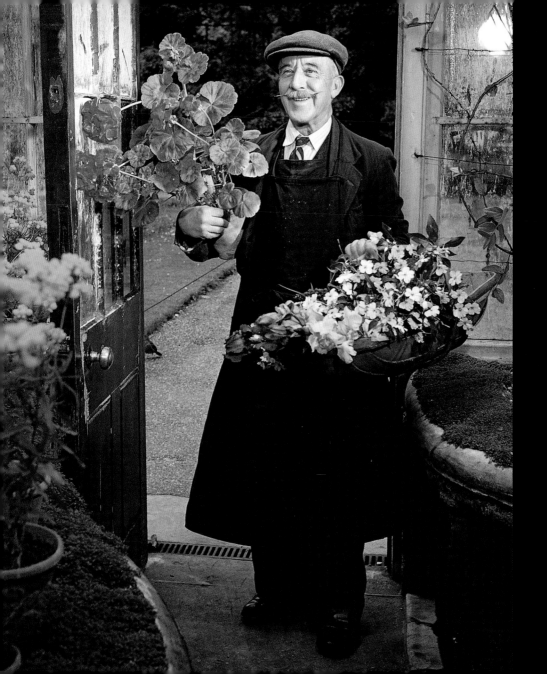

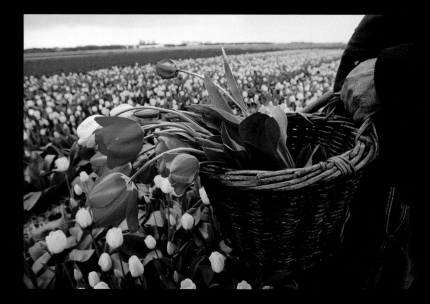

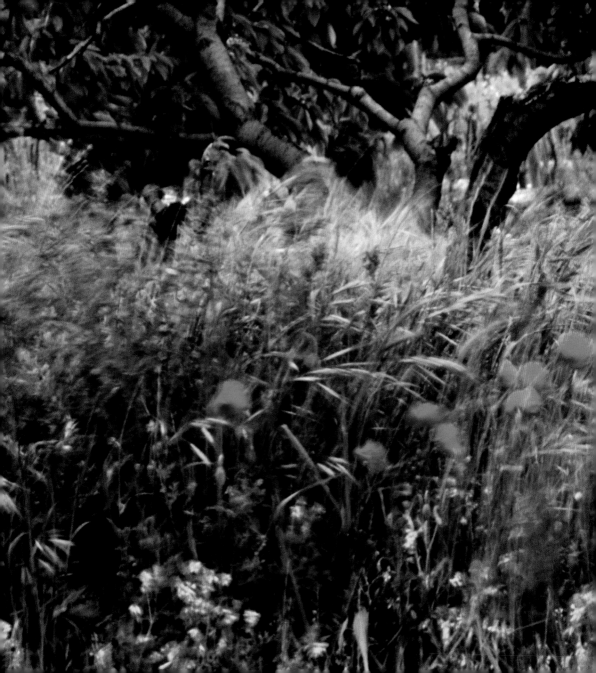

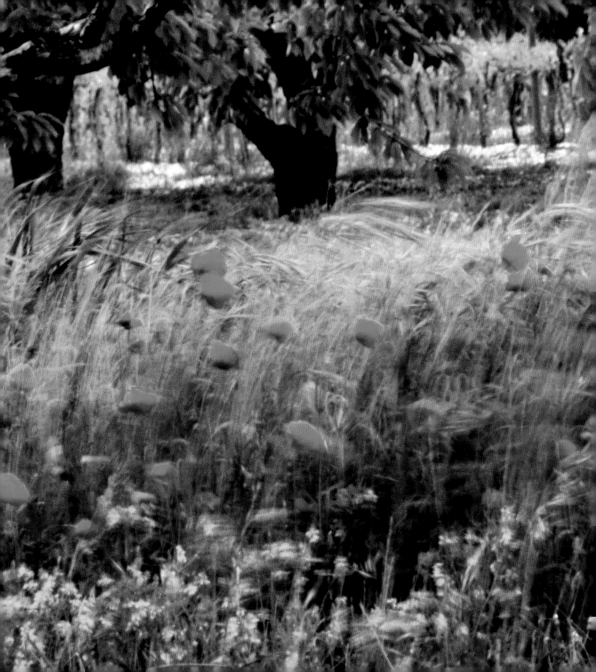

CHARLOTTESVILLE,
VIRGINIA
1987
SAM ABELL

preceding pages
PROVENCE, FRANCE
1995
WILLIAM ALBERT ALLARD

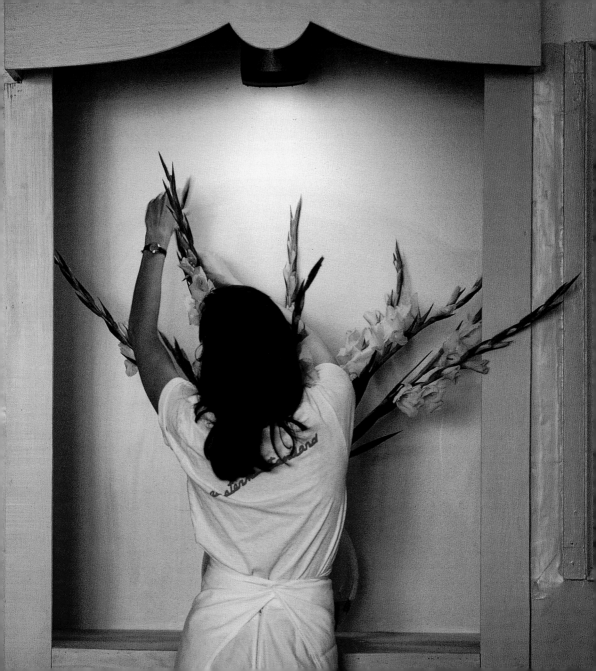

WASHINGTON, D.C.
1931
CHARLES MARTIN

following pages
CALIFORNIA
1912
GEORGE G. MCLEAN

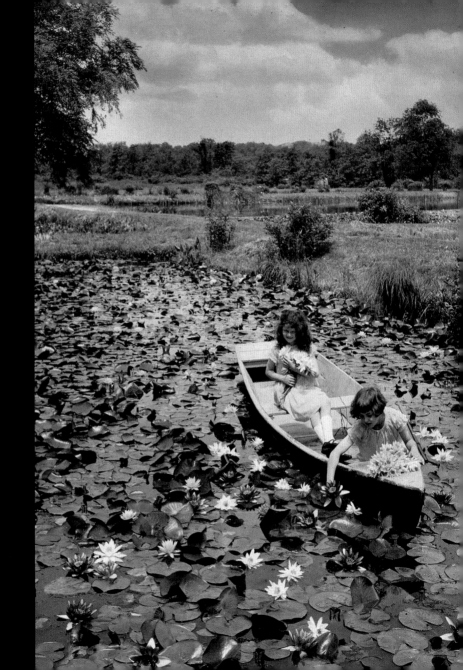

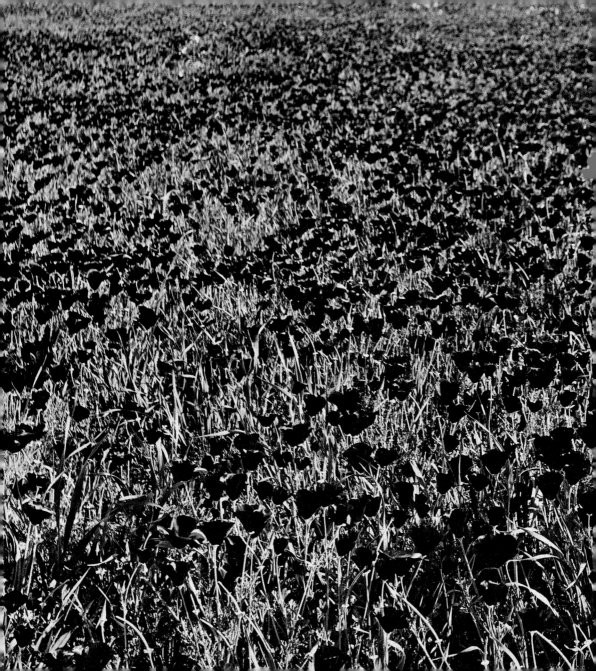

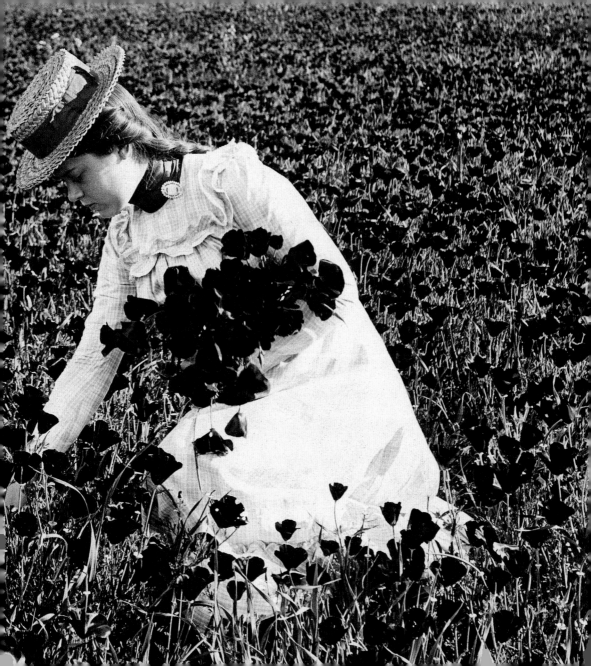

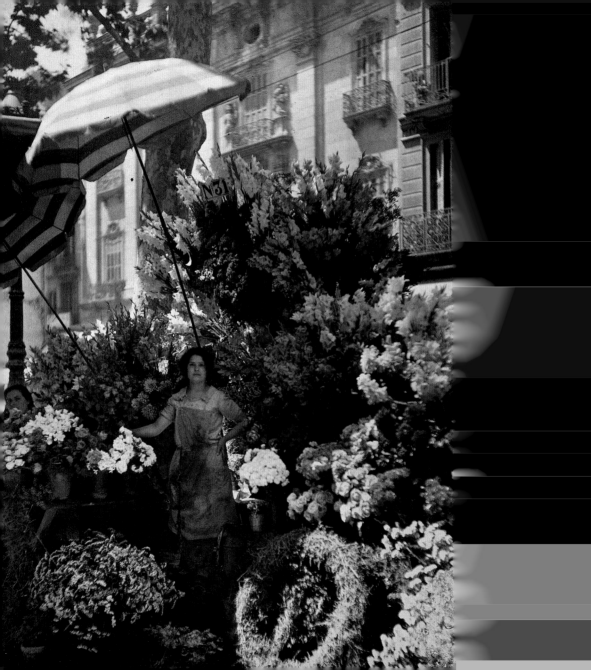

BARCELONA, SPAIN
1929
GERVAIS COURTELLEMONT

KALINGRAD
1997
DENNIS CHAMBERLIN

following pages
SAN FRANCISCO,
CALIFORNIA
2001
SISSE BRIMBERG

WASHINGTON, D.C.
2000
SAM ABELL

NAPLES, ITALY
1998
DAVID ALAN HARVEY

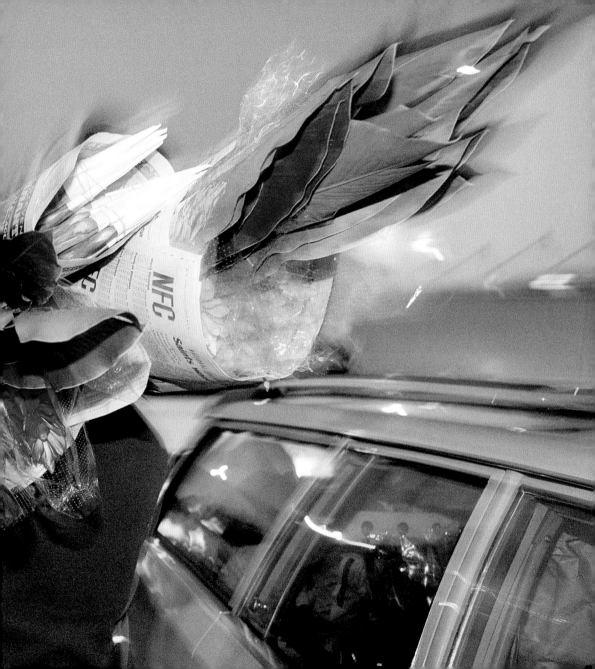

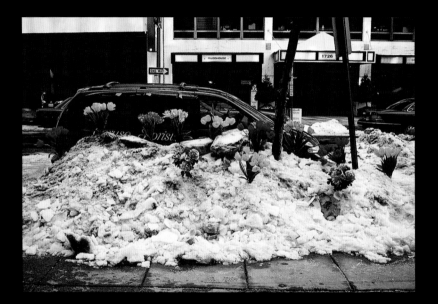

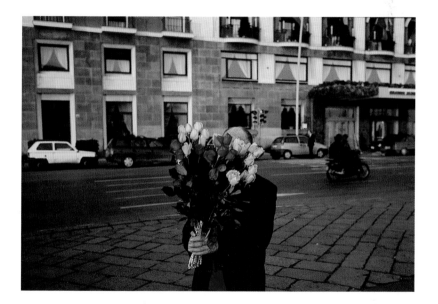

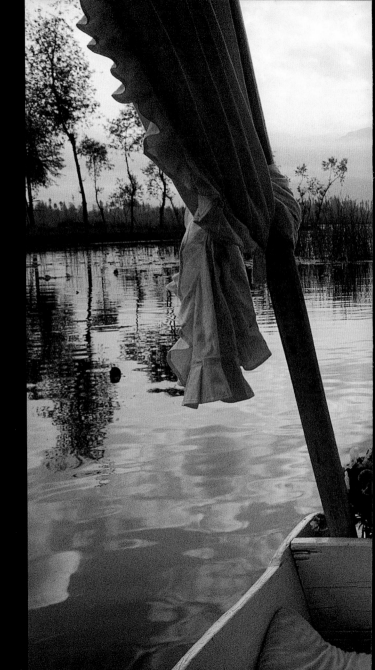

KASHMIR, INDIA
1989
SAM ABELL

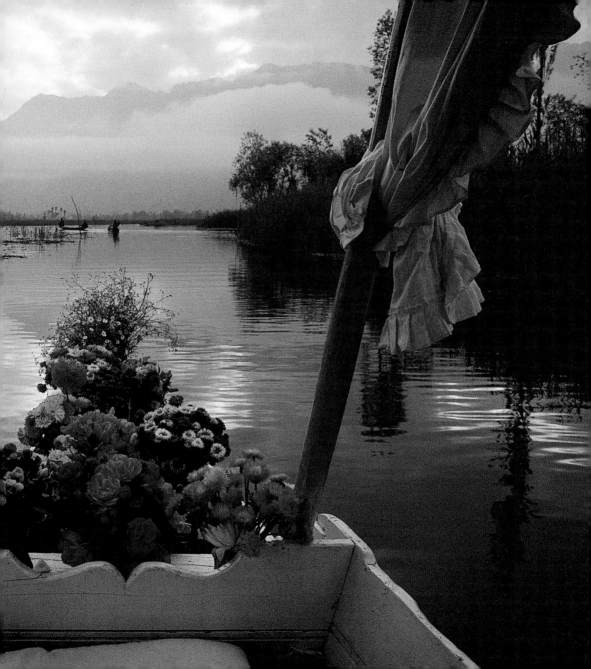

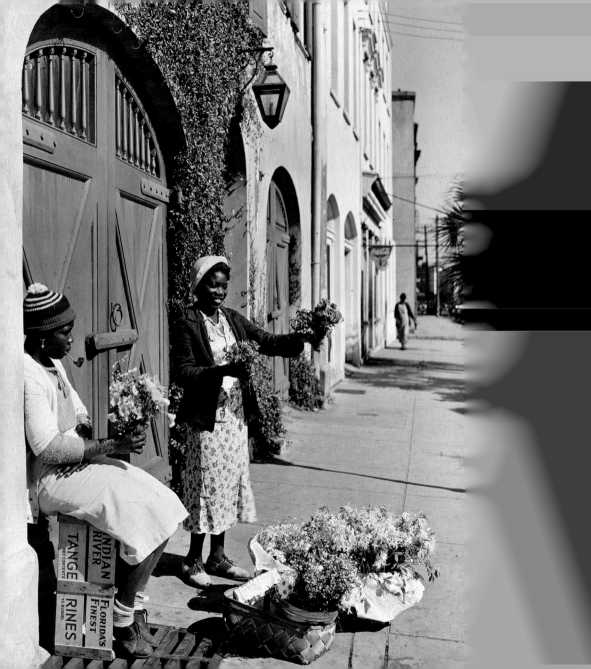

CHARLESTON,
SOUTH CAROLINA
1939
B. ANTHONY STEWART

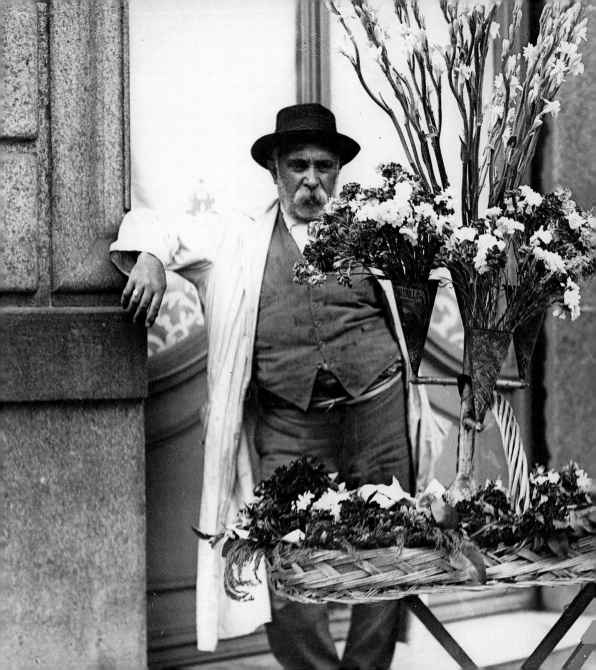

ARGENTINA
1920
PUBLISHERS
PHOTO SERVICE INC.

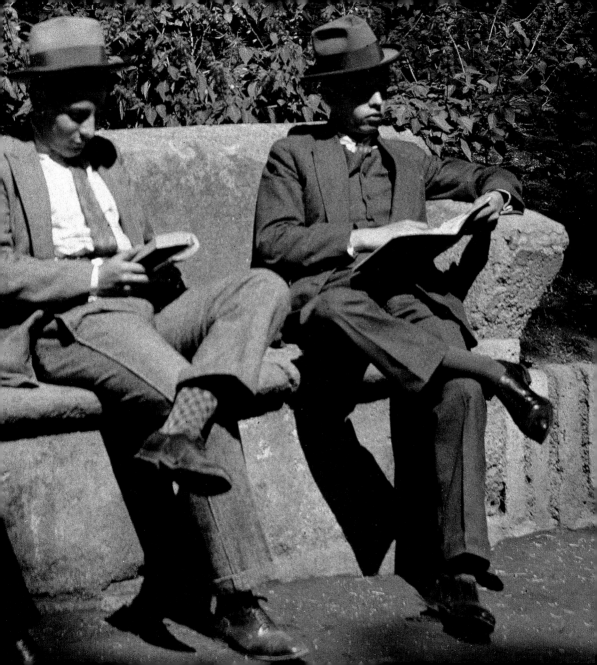

DECS, HUNGARY
1932
RUDOLF BALOGH

preceding pages
SANTIAGO, CHILE
1929
JACOB GAYER

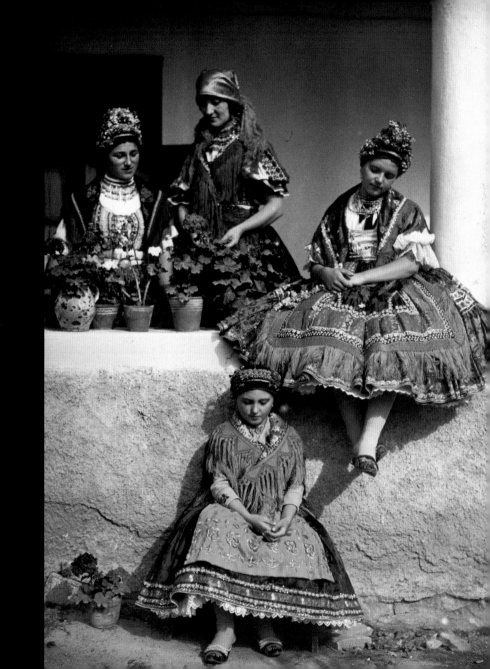

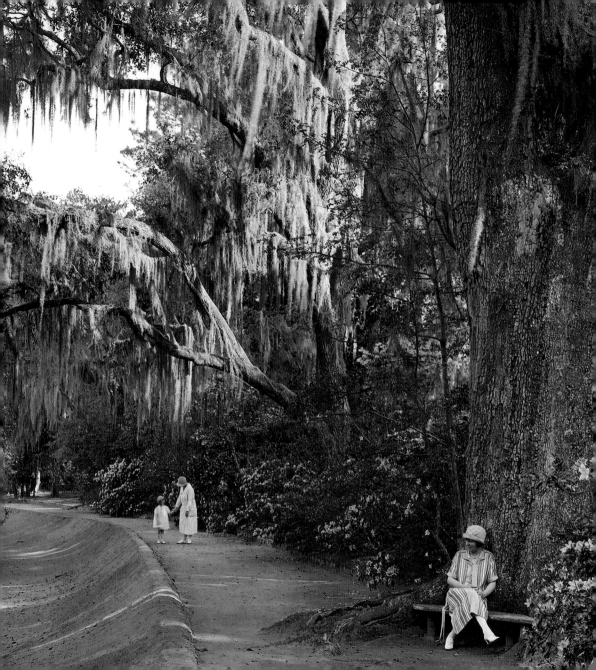

ASHLEY RIVER,
SOUTH CAROLINA
1926
JACOB GAYER

following pages
WESTERN AUSTRALIA
1995
CARY WOLINSKY

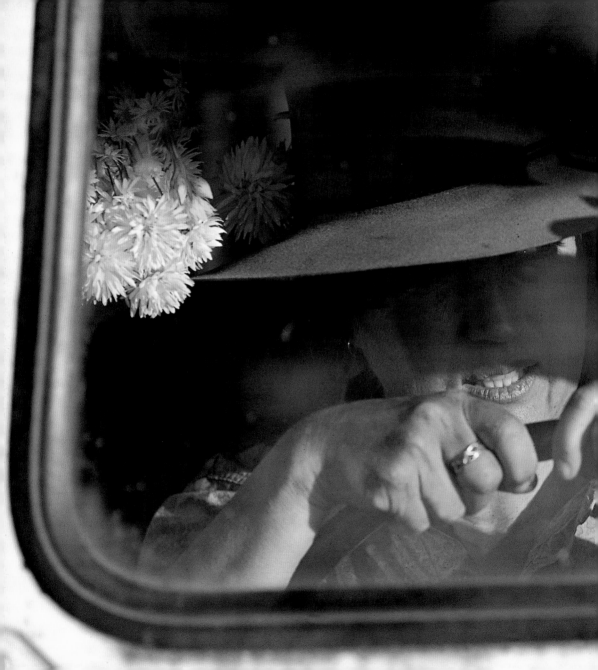

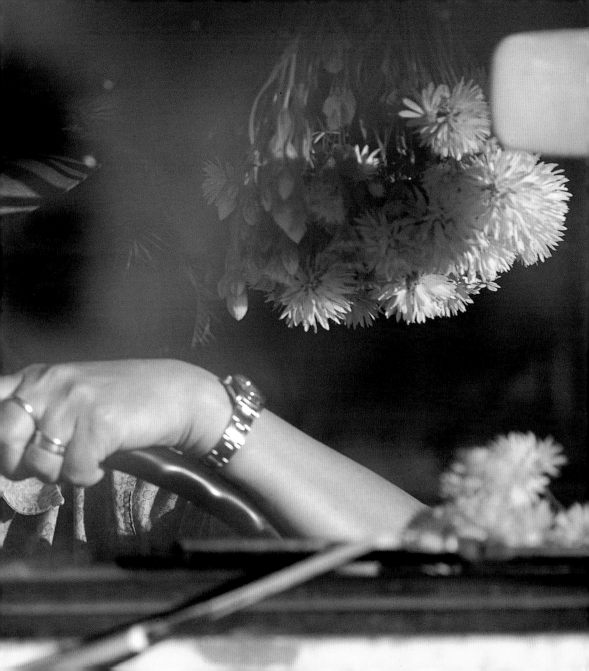

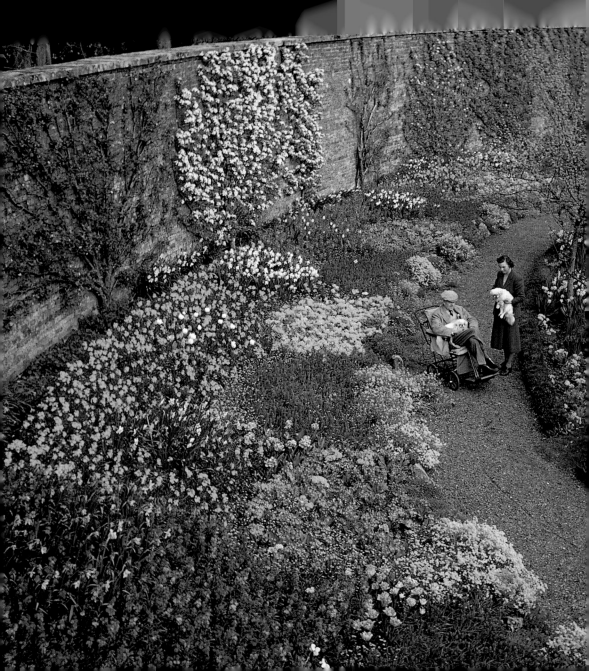

BARGANY, SCOTLAND
1954
B. ANTHONY STEWART

MAJORCA
1957
FRANC AND JEAN SHOR

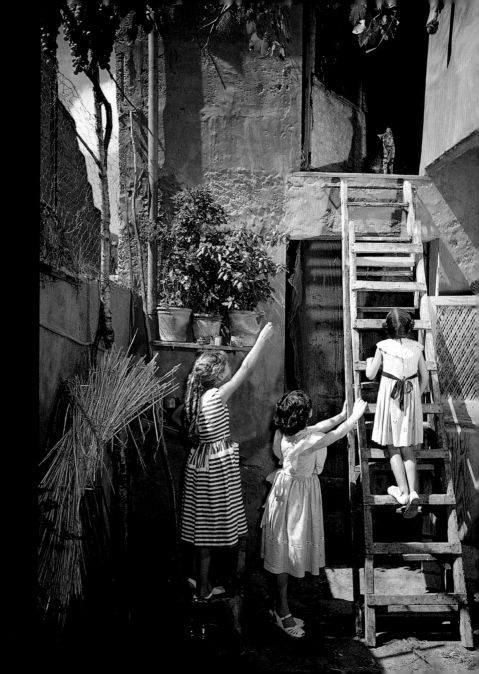

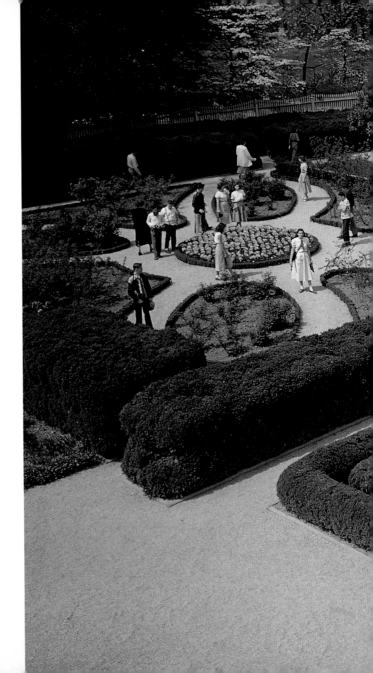

MOUNT VERNON,
VIRGINIA
1953
JOHN E. FLETCHER

following pages
CHARLESTON,
SOUTH CAROLINA
1939
B. ANTHONY STEWART

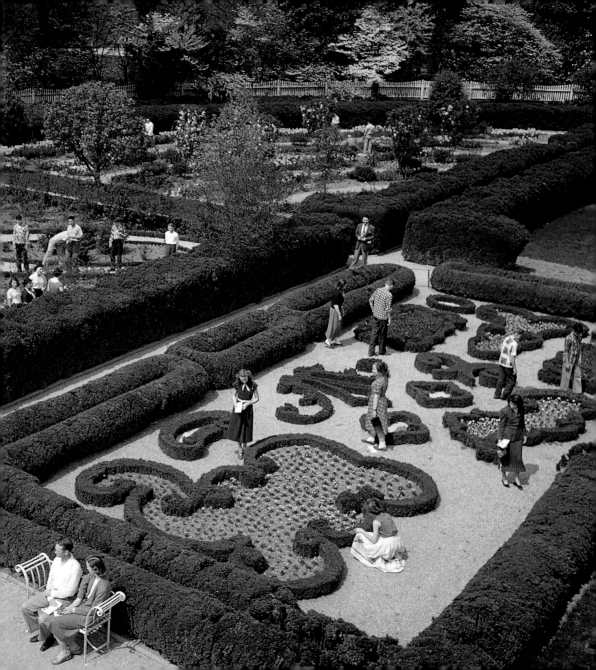

Gardens
by Leah Bendavid-Val

Published by the National Geographic Society
John M. Fahey, Jr., *President and Chief Executive Officer*
Gilbert M. Grosvenor, *Chairman of the Board*
Nina D. Hoffman, *Executive Vice President*

Prepared by the Book Division
Kevin Mulroy, *Vice President and Editor-in-Chief*
Marianne R. Koszorus, *Design Director*
Leah Bendavid-Val, *Editorial Director, Insight Books*

Staff for this Book
Leah Bendavid-Val, *Editor*
Rebecca Lescaze, *Text Editor*
Marianne R. Koszorus, *Art Director*
Vickie Donovan, *Illustrations Editor*
Joyce M. Caldwell, *Text Researcher*
R. Gary Colbert, *Production Director*
John T. Dunn, *Technical Director, Manufacturing*
Richard S. Wain, *Production Project Manager*
Sharon C. Berry, *Illustrations Assistant*
Natasha Scripture, *Editorial Assistant*

We would like to give special thanks to Susan E. Riggs,
Bill Bonner, and Patrick Sweigart for their hard work and
generous support for this project.

One of the world's largest nonprofit scientific and edu-
cational organizations, the National Geographic Society
was founded in 1888 "for the increase and diffusion of
geographic knowledge." Fulfilling this mission, the Soci-
ety educates and inspires millions every day through its
magazines, books, television programs, videos, maps
and atlases, research grants, the National Geographic
Bee, teacher workshops, and innovative classroom mate-
rials. The Society is supported through membership dues,
charitable gifts, and income from the sale of its educa-
tional products. This support is vital to National Geo-
graphic's mission to increase global understanding and
promote conservation of our planet through exploration,
research, and education.

For more information,
please call 1-800-NGS LINE (647-5463)

or write to the following address:

1145 17th Street N.W.Washington, D.C. 20036-4688
U.S.A.

Visit the Society's Web site
at www.nationalgeographic.com.

Front Jacket and title page: Northern Ireland/1993/Sam Abell

Additional Credits: p. 64, All Year Club of Southern California; pp. 134-135 & Back
Jacket, CORBIS

tionalgeographicmomentsGARDENSnati
RDENSnationalgeographicmomentsGAR
omentsGARDENSnationalgeographicmor
ographicmomentsGARDENSnationalgeo
ationalgeographicmomentsGARDENSna
entsGARDENSnationalgeographicmomer
aphicmomentsGARDENSnationalgeograp
nalgeographicmomentsGARDENSnationa
RDENSnationalgeographicmomentsGAR
omentsGARDENSnationalgeographicmor
raphicmomentsGARDENSnationalgeogra
ationalgeographicmomentsGARDENSna
entsGARDENSnationalgeographicmomer
hicmomentsGARDENSnationalgeograph
nalgeographicmomentsGARDENSnation
RDENSnationalgeographicmomentsGAR
omentsGARDENSnationalgeographicmor
ographicmomentsGARDENSnationalgeo